IMAGES
of America

WINDSOR

from JCL
2008

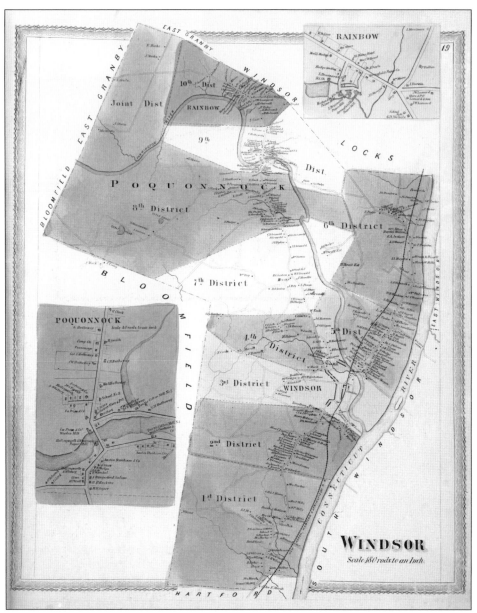

Baker and Tilden published this map of Windsor in its *Atlas of Hartford City and County* in 1869. Windsor's population then was about 2,800 people, and the names of many of the property owners were recorded on the map. Each village center had its own identity. Today Windsor's population is approximately 28,000. From its beginnings as a small settlement, the town has evolved into a thriving agricultural, commercial, and suburban community.

On the cover: Commanding a prominent location on Broad Street Green in Windsor Center, the Hotel Windsor (later known as the Windsor House) was a popular destination for 160 years. In the early part of the 20th century, photographer Ralph W. Frost lived in rooms near the green and worked as a clerk at the Hotel Windsor. He took a number of engaging images of the hotel, its owner Owen Eagan, and Eagan's friends and family. (Windsor Historical Society Collections.)

IMAGES
of America

WINDSOR

Windsor Historical Society

ARCADIA
PUBLISHING

Published by Arcadia Publishing
Charleston SC, Chicago IL, Portsmouth NH, San Francisco CA

Printed in the United States of America

Library of Congress Catalog Card Number: 2007924484

For all general information contact Arcadia Publishing at:
Telephone 843-853-2070
Fax 843-853-0044
E-mail sales@arcadiapublishing.com
For customer service and orders:
Toll-Free 1-888-313-2665

Visit us on the Internet at www.arcadiapublishing.com

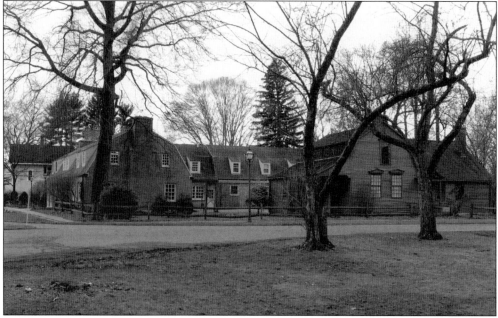

Since 1921, the Windsor Historical Society has sought to engage Windsor residents and the descendants of its original founders with the history of this special community. Its facilities now include the Marguerite Mills building (left), which houses two exhibition galleries, office space, and an extensive research library. A small gift shop leads visitors into the Leland P. Wilson building (center) where the Hands-On-History room provides activities for families and a meeting space for public programming. The 1758 John and Sarah Strong House (right) originally served as the society's headquarters. Today it is furnished with decorative arts from the 18th and 19th centuries. It is open for tours together with the 1767 Hezekiah Chaffee House just across Palisado Green.

CONTENTS

ACKNOWLEDGMENTS

The Windsor Historical Society staff members who compiled this book, Christine Ermenc, Barbara Goodwin, Erin Stevic, and Connie Thomas, received indispensable assistance and encouragement from many people during its preparation.

Most of the photographs are from the extensive collections of the Windsor Historical Society. Many were selected from the Howes Brothers, Ralph W. Frost, and William S. Leek Collections. However, we are grateful to the following individuals and organizations in the community who loaned images and gave permission for their use: William Best and Monica Levy; the Brown and Martin families; the Endee and Peters families; Edward W. Mack IV; Al Narcisse; Nellie and Julius Rusavage; the Connecticut Historical Society Museum; and the Luddy/Taylor Connecticut Valley Tobacco Museum. Wayne Dombkowski Photography of Windsor and Gerrick Photographers of West Hartford provided original and reproduction photographic services. Al Boehm prepared the map of Windsor villages.

Particular recognition goes to those who helped with the research. Their enthusiasm for the project and willingness to dig out just one more fact or source was very much appreciated. Thanks to Elaine Brophy, Beverly Garvan, Mary Clark Giffin, Shirley Grossman, Nicole Heroy, Sandy McGraw, Marion Nielsen, Elizabeth Parker, and Mary Ellsworth Ransom. Many other volunteers, named and unnamed, helped with a variety of tasks from pulling photographs to editing text. They include Kathy Bostwick, Charles Goodwin, Ruthann Graime, James Pierson, Susan Smoktunowicz, and James Trocchi. Lastly we are especially grateful to our student intern Nicole Heroy for cheerfully scanning the photographs.

The Windsor Historical Society has written this book to complement the town's 375th anniversary celebration in 2008. It is our hope that this pictorial survey will introduce members of the community to Windsor's rich and fascinating history and stimulate them with a desire to explore it further.

All of the resources listed on the bibliography page are available for use at the Windsor Historical Society's research library. The society's collections also include genealogies, manuscript collections, cemetery records, town reports, local newspapers, school yearbooks, city directories, and maps that document the history of Windsor and the everyday lives of its people.

INTRODUCTION

Windsor, Connecticut's oldest English settlement, celebrates 375 years of existence in 2008. This book pays tribute to a town that has evolved from a remote frontier outpost established in 1633 to a suburban community that treasures and safeguards its own distinctiveness. Photographs from the Windsor Historical Society's extensive collections form the backbone of this book, and most date from between 1890 and 1930. Rather than a comprehensive history of the town, this work is a resource designed to whet historical appetites of old-timers, newcomers, and visitors alike.

Anyone exploring Windsor's past soon realizes how land and water shaped settlement, drawing first the Native Americans and then English explorers and settlers to this fertile area at the juncture of the Connecticut and Farmington Rivers. Today the town of Windsor encompasses 30 square miles of land. In the 17th century, the town's geographic boundaries stretched from Litchfield to Tolland. These boundaries contracted as early settlers grew weary of jolting over rutted roads and braving swollen rivers to get to Windsor's center to attend church and participate in town meetings. Over the years, 20 separate "daughter" towns have formed from what was once the town of Windsor.

In its earliest years, Windsor was a frontier settlement at the very edge of what English settlers thought of as the civilized world. Survival required fortitude. Agriculture was a key to that survival and a way of life in Windsor's early years. The community was largely self-sufficient in its early days, with farmers doubling as millers, woodworkers, potters, blacksmiths, and more. By virtue of its location on navigable rivers, trade was a growing part of Windsor's economy. The influence of the outside world began to have consequences. On the positive side, discomforts and isolation lessened as new goods and new ideas came to town. Trade's negative impact was seen in diseases that decimated the region's Native Americans and as the enslavement of Africans by the wealthy became acceptable.

Windsor's development mirrors the pattern of many American towns with its economy gradually evolving from subsistence farming to larger scale agricultural, industrial, and commercial enterprises. In the early days, transportation was limited to river and oceangoing vessels or horse-drawn transport over dirt roads and pathways. Windsor, like other American communities, was isolated and developed a distinctive town identity largely undiluted by outside influences. As centuries progressed, newer, faster, and more efficient forms of transportation stimulated trade and eased communication as well as travel, linking Windsorites with the world beyond. Today a global economy renders the nation increasingly homogeneous, yet Windsor's story remains distinctive in a number of ways.

From its earliest days, demographic and geographic diversity figured prominently in town history. Windsor was founded by three waves of settlers arriving closely on one another's heels in the 1630s. Traders from Plymouth, Massachusetts, were the first to build a settlement. Eventually they were bought out by a group from Dorchester, Massachusetts, that included the founders of First Church. A third group, the Lords and Gentlemen under the auspices of Lord Saltonstall, arrived soon after to settle north of the Dorchester group.

It was, perhaps, inevitable that a large town like Windsor would develop five smaller village centers, including Windsor Center, Poquonock, Rainbow, Hayden Station, and Wilson, each with its own distinctive character. Windsor, unlike most New England towns, has two separate town greens. Palisado Green, the original town center, lies close to the Farmington River, which was the town's major transportation artery. It was the commercial, civic, and religious heart of town until the mid-19th century. At that point, the coming of the railroad and the construction of the railroad station led commercial activity southward to the previously residential Broad Street Green area. Palisado Green is now the residential heart of Windsor Center's historic district, while Broad Street Green has become the center of the town's business district. In the 19th century, mills and factories sprang up along the Farmington River, drawing migrants from other states and even from across the seas to the village of Poquonock. Today Windsor, which is considered a suburb of Hartford, is still known for its demographic diversity.

Over the years, the land itself fostered enterprise and entrepreneurship. Abundant clay deposits in Windsor soils supported the development of close to 40 flourishing brickyards by the 1830s. The first shade-grown tobacco produced in this country was grown under cheesecloth tents in the village of Poquonock in 1900. The tents blocked direct sunlight and increased humidity, thus approximating the optimal growing conditions of the plants' native Sumatra. Another innovation involved electric power generated at Rainbow Dam. In 1889, Edward Terry proved that electricity could be transmitted 11 miles to the Hartford Electric Company power station, which proved to scientists across the country that electric transmission over long distances was viable for commercial use. Windsor's H. Sidney Hayden significantly improved the quality of life for many late-19th-century town residents by establishing the Young Ladies' Institute on Broad Street Green, starting Windsor's first volunteer fire company, organizing the Windsor Water Company, and giving the town a home for its poor.

Windsor's past and its status as the first English settlement in Connecticut remain important in town. The Martha Pitkin Wolcott chapter of the Daughters of the American Revolution opened the Oliver Ellsworth Homestead as a public museum in 1903. Windsor Historical Society formed in 1921 to gather materials for the town tercentenary celebrations in 1933. When a historic house on Palisado Green was threatened with demolition to make way for a gasoline station in 1925, society members mobilized to save it. First Church in Windsor and the Fyler House (now known as the John and Sarah Strong House) have become anchors of the town's historic district. Tercentenary celebrations of First Church in 1930, the town in 1933, and the village of Poquonock in 1949 were marvelous affairs. Parades, floats, pageants, and a floating replica of the 17th-century vessel *Mary and John* that brought First Church congregants from England to the New World are captured in photographs, on film, and special anniversary newspaper editions.

The authors hope this book will encourage people to identify and preserve photographs that will become historic records for their families and communities. Community members who donated images or allowed the society to make copies of their photographs have built the society's photographic collections; however, there are many gaps in the collections, and the society hopes to assemble the most comprehensive record possible of Windsor's history. Photographs are a wonderful resource, lending immediacy and warmth to history. They show us that in the end, Windsor residents were, are, and will continue to be just ordinary people who work, play, build homes, raise families, plan for the future, and interact with others to form the vital community that is Windsor.

—Christine Ermenc, Barbara Goodwin, Erin Stevic, and Connie Thomas

One

LAND, RIVERS, AND EARLY SETTLERS

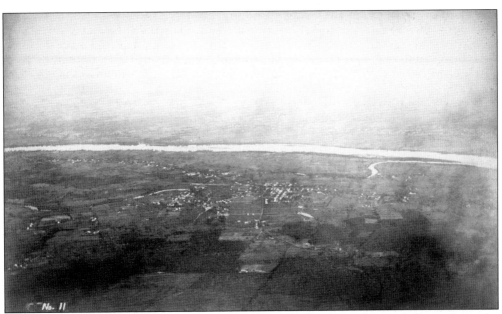

This 1885 aerial view of Windsor, taken by Thomas Doughty from a hot-air balloon, shows the Connecticut River bisecting the image. Its name meant "long tidal river" to the Native Americans. In 1633, English businessmen from Plymouth, Massachusetts, arrived to trade for furs with the Native Americans. They settled near where the smaller Farmington River joined the Connecticut (right, center). Bordering the Connecticut River were acres of uninhabitable but fertile lands that flooded yearly as snow melted in New England. It was the promise of this rich soil that attracted more English settlers in 1635. (Courtesy Connecticut Historical Society Museum.)

This early-1900s photograph shows the Farmington River looking north from Batchelder Road. Notice the poles securing fishing weirs for capturing shad. In the 1600s, Native Americans used the Farmington River for transportation and as a source for fishing and hunting. They camped nearby and cultivated the adjoining fields. When Europeans moved into the area in the early 1600s, the Native Americans contracted smallpox and over 90 percent of them died.

It was vistas such as this that attracted English settlers to Windsor in 1635. Large plots of land were purchased from the local Native Americans and redistributed among Windsor's early families. Home lots were located on the higher elevations along today's Route 159. Lower-lying fields that flooded annually in the spring were left with a fine, rich silt and cultivated with crops of grain.

In the 1630s, there was intense competition between European nations for control of Connecticut River trade. The Dutch held the Hartford area. In 1633, when John Holmes from the colony at Plymouth, Massachusetts, sailed past the Dutch fort, his ship was fired on but sustained no damage. Proceeding north, he established a trading post on the Connecticut River's west bank in an area the Native Americans called Matianuck, later renamed Windsor.

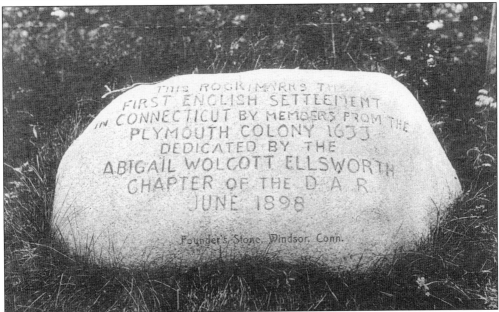

Following the nation's 1876 centennial, there was a surge of interest in the nation's past. Large numbers of immigrants moved into New England villages to fill factory jobs and changed the character of every town. This 1898 monument, located on the Loomis Chaffee School campus, commemorates the 1633 settlement of Windsor and was installed by the local chapter of the Daughters of the American Revolution.

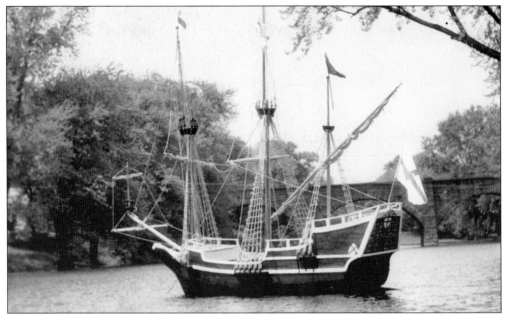

In 1630, members of First Church sailed from England on the ship *Mary and John* and settled in Dorchester, Massachusetts. Five years later, they walked overland and established home lots on today's Palisado Green along Palisado Avenue (Route 159). In 1930, the church celebrated that transatlantic crossing to the New World with a pageant featuring a one-sixth-size replica of the ship *Mary and John* and moored it in the Farmington River.

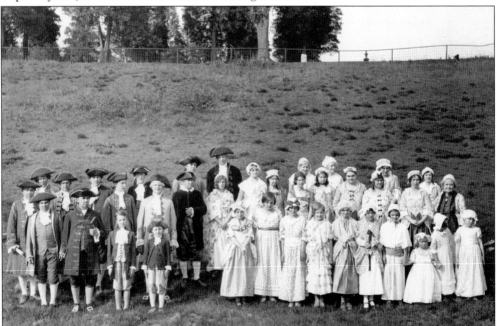

In 1633, Pilgrims from the Plymouth, Massachusetts, colony sailed to what is now Windsor, established a trading post, and traded with the Native Americans. The town celebrated its English beginnings 300 years later with religious services, a 50-float parade attended by Gov. Wilbur Cross, a ball, and speeches.

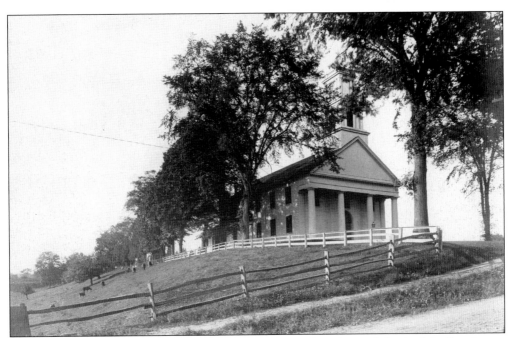

The First Church in Windsor's 1794 meetinghouse is situated on the north bank of the Farmington River on Palisado Avenue. The congregation traces its roots to the English immigrants who crossed the Atlantic in 1630 on the ship *Mary and John* before removing to Windsor in 1635. This is the fourth church building constructed by the congregation.

Town clerk and surveyor Mathew Grant (1601–1681) left a diagram of the home lots around the Palisado Green. These homes were grouped together within a palisade or stockade fence for protection from the Native Americans. The settlers' fields and woodlots were outside. Windsor settlers were never attacked, but they formed an army with the Hartford and Wethersfield settlements. Maj. John Mason led the group during the 1637 Pequot War.

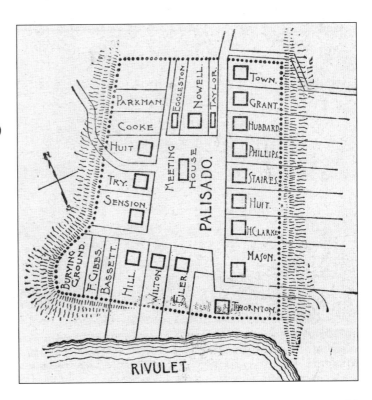

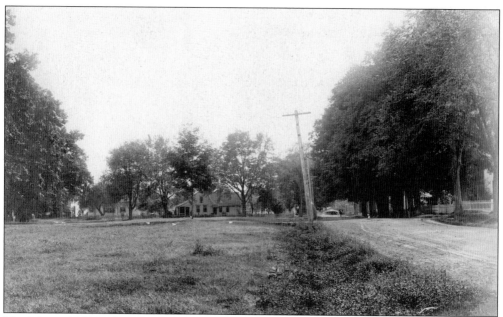

Until the mid-1800s, the Palisado Green north of the Farmington River was the town's commercial center. Oceangoing vessels were loaded with Windsor bricks, livestock, and firewood. Returning ships brought molasses, sugar, rum, and fabrics that were sold in small shops. The Strong house (center) was the home of sea captain Nathaniel Howard. It housed his wife's general mercantile shop and was the town's first post office.

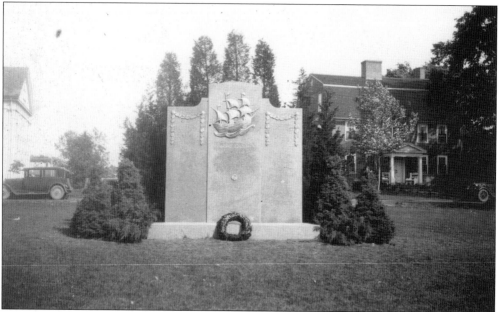

The Founders Monument, installed on the Palisado Green in 1930, was commissioned by the National Society of Sons and Daughters of the Pilgrims and designed locally by Evelyn Batchelder. It lists 125 names of Windsor's founding families and faces west as did those families when they crossed the Atlantic in 1630. A bronze replica of their ship, the *Mary and John*, sits at the top.

14

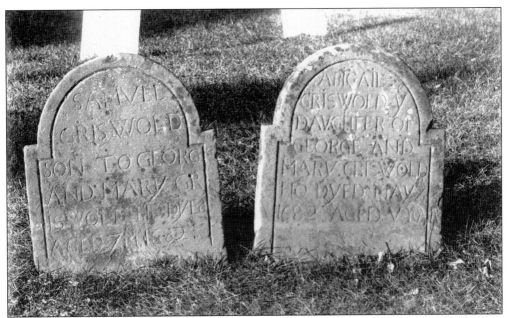

Gravestones in Windsor's early cemeteries are visible traces of the town's 17th-century settlers. These early markers were made of sandstone, probably quarried nearby, and displayed no religious imagery, which was a concept embraced by Puritans. In the 17th century, burying grounds were intentionally not placed near the Puritan meetinghouses. Stonemason George Griswold cut these two 1682 headstones for the youngest of his 10 children, Samuel and Abigail.

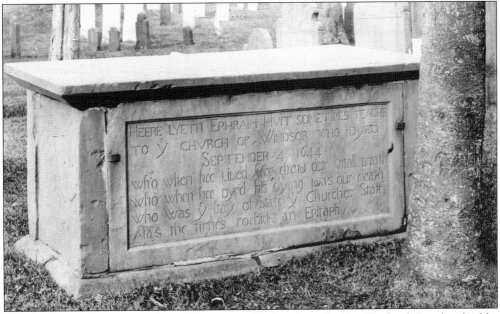

Windsor's Puritan settlers followed the customs of their homeland in England. People of public and social importance had gravestones reflective of their earthly status. This 1644 table stone is befitting of Ephraim Huit, the First Church minister. His grateful congregation inscribed, "Who when he lived, wee drew our vitall breath, who when hee dyed, his dying was our death." The reverse side commemorates the life of Huit's colleague, Rev. John Warham, who died in 1670.

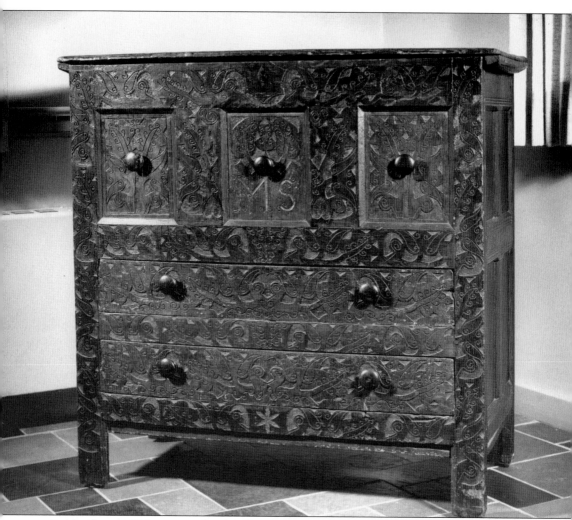

A relic from a 17th-century family, this chest passed through matrilineal lines until it was donated to the Windsor Historical Society in the 1960s. Typically female heirs inherited household items while male heirs inherited land, barns, houses, and outbuildings for farming. Though created in Hadley, Massachusetts, the image of this chest illustrates the skills of the English woodworkers who settled in Windsor in the 17th century. The talented woodworkers produced framed houses, wagon wheels, barrels, and turned furniture. Thirty-five percent of the town's males were woodworkers, and their families formed strong kinship bonds when the woodworkers' sons married the daughters of other woodworkers. This chest was made for Mary Smith of Hadley, Massachusetts, prior to her 1708 marriage to Thomas Sheldon Jr. Its purpose was to hold household linens and clothing. The floral-and-vine-decorated chest has a top and sides made of oak while yellow pine is used for the secondary pieces.

Two

AGRICULTURE

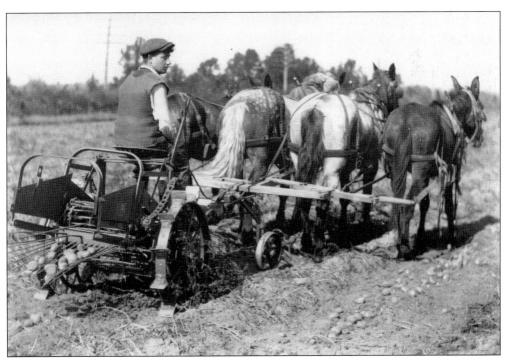

Agriculture has been an integral part of Windsor's history and economy since the town's earliest days. The first settlers were subsistence farmers, growing just enough livestock, field crops, and foodstuffs for their needs. Later generations increased the size of their farms and grew tobacco and horticultural nursery stock to sell to national and international markets. Windsor residents enriched the local economy by catching shad and salmon in the rivers, harvesting lumber, and expanding dairy and poultry farms. Today many acres of open land have been converted from agricultural uses to office parks and housing developments.

Small family farms were very common and were scattered over all of Windsor. Cleared and fenced fields, dirt lanes, and a small flock of hens may seem unusual and picturesque in the 21st century, but the scene was likely to be repeated often as one traveled the town's roadways in 1900.

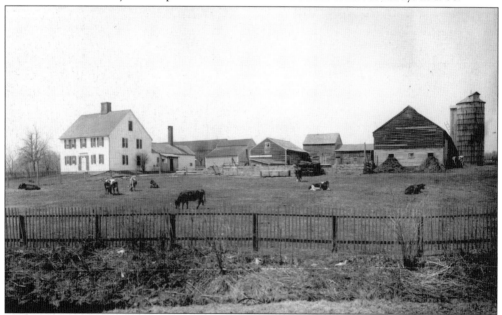

Several generations of an extended family sometimes built up a complex of buildings. A home with an ell, carriage sheds, barn, silo, and assorted outbuildings comprised a larger farmstead. The once-forested Windsor lands were cleared as the residents prepared fields for crops and pastures and used the wood for constructing and heating their homes. The average Colonial family used 30-40 cords of wood each year.

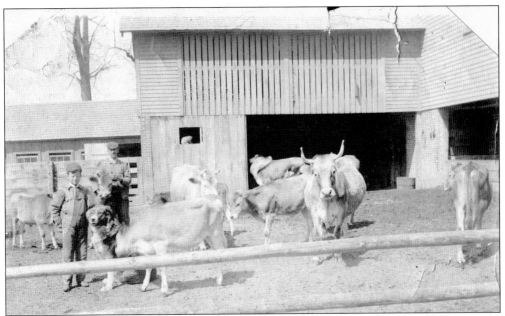

William Filley's farm was located along Elm Street and Filley Street between Broad Street and Cook Hill. The farm and its dairy herd were a prominent feature in the center of Windsor well into the 20th century. Carlan Goslee (left), age 10, posed with Joseph Filley and the faithful dog in the barnyard in 1896. Reportedly there were more than enough cows in town to supply the local creamery.

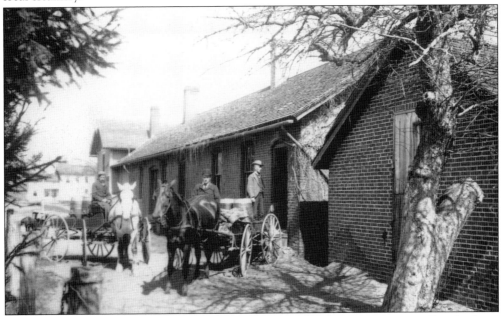

The Windsor Creamery Company was organized in 1885 as a cooperative effort by local dairymen. Milk was brought to the creamery by wagon in large cans, processed into butter, and supplied to Hartford families. It was located on today's Batchelder Road south of the library near Creamery Brook. Set into the hill, the building appeared to be one story high on the south side and two stories high on the north.

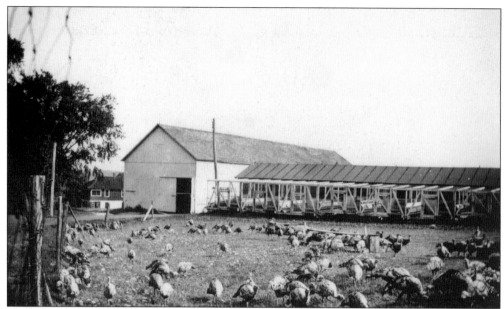

Cows and chickens were raised on many family farms, but in 1928, Howard C. Thrall of Poquonock Avenue started a new industry in Windsor—raising turkeys. He was an active leader in the Connecticut Turkey Growers Association and sold his "Connecticut Native Fancy Grade" birds in several grocery stores in the Hartford area at Thanksgiving and Christmas.

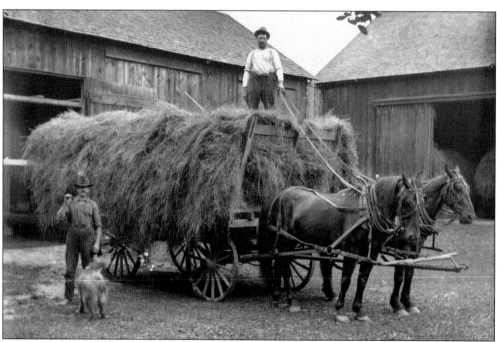

Hay wagons piled high with fragrant dried grass were a familiar sight. Enormous amounts of hay were needed to feed livestock throughout the long winters. Children enjoyed the privilege of riding on the load of hay, but to the little ones it seemed very high and slippery. By the age of 10 or 12, the youngsters were learning to drive the team of horses and help with the haying.

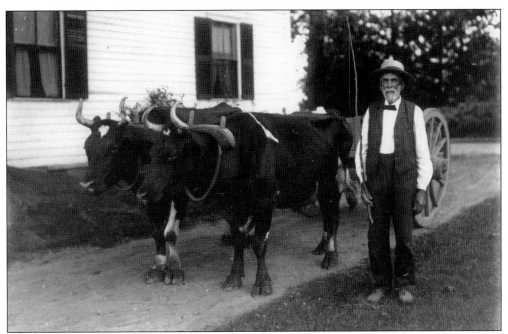

Oxen were used as draft animals for tasks such as plowing, hauling logs, or pulling a cart, tasks for which a modern farmer might use a tractor. Full-grown oxen could pull about two-and-one-half times their own weight. Timothy Phelps posed with his team near his home at 204 Palisado Avenue about 1907. Reputedly Phelps had one of the last yokes of oxen in Windsor.

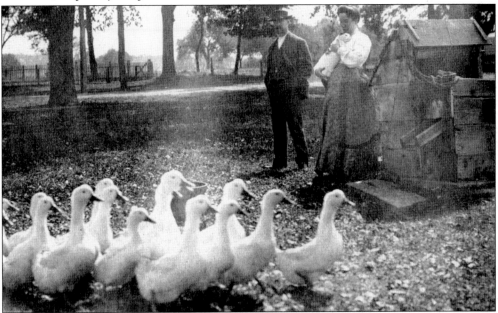

A variety of fowl ranging free in the poultry yard supplied this family with eggs, meat, and feathers. The soft, fluffy layer of tiny feathers found on the underbellies of geese and ducks is called down and was used for stuffing pillows. A featherbed required the down from as many as 140 geese. Rabbits are sometimes raised for meat, but it appears that this woman's rabbit was her pet.

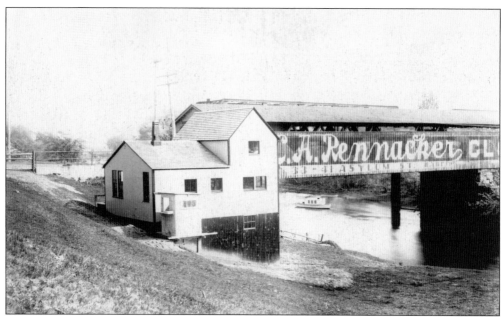

American shad migrate from the ocean back to their freshwater birthplace to reproduce. The April to June shad run was an important source of food, and tons of the silvery fish were shipped to city markets. The shad population was seriously affected by dams and water pollution from manufacturing industries. This shad hatchery by the Farmington River bridge was an early example of state efforts to restore the shad run.

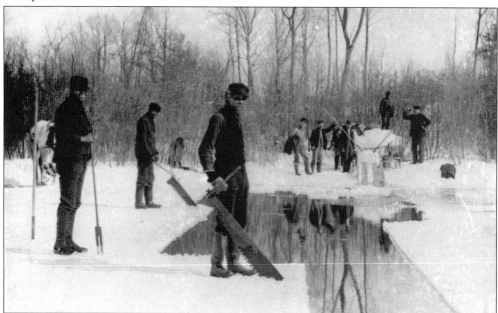

In winter, the still waters of local ponds yielded ice—a luxury that became a necessity. When the ice was at least eight inches thick, specialized saws and axes were used to cut the heavy blocks. These were hauled to an icehouse for storage, and sawdust or straw was spread between the layers for insulation. Several ponds in town yielded ice, including one just north of River Street in Poquonock.

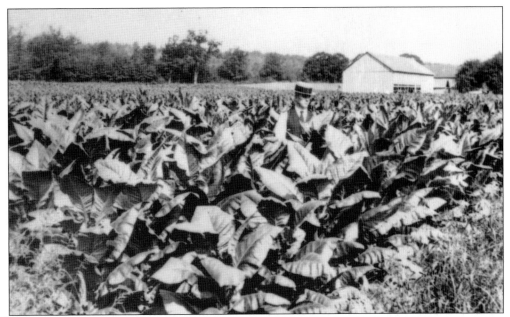

Native Americans were growing and using tobacco long before English colonists arrived in the Connecticut River Valley. The first settlers quickly learned from them and were raising tobacco as early as 1641. The sandy loam of central Connecticut was ideal for growing tobacco. Increasing acreage was devoted to the cultivation of broadleaf and later to shade-grown varieties. Windsor tobacco has generally been used for the two outside layers of cigars.

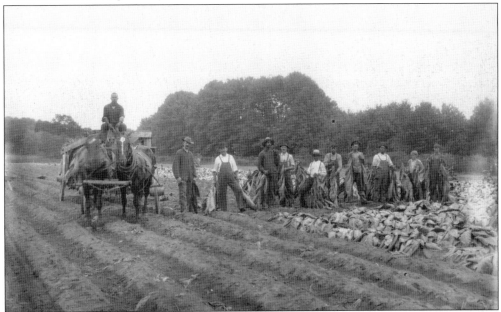

Broadleaf tobacco plants grow about four feet tall. The whole plant was cut down with a hatchet, and the lower end of the thick stalk was speared onto a thin wooden lath. Each lath, heavy with tobacco plants, was hung upside down across a frame on the horse-drawn wagon and pulled to the shed for drying. These men are harvesting broadleaf tobacco on the Daniel W. Barnes farm in 1898.

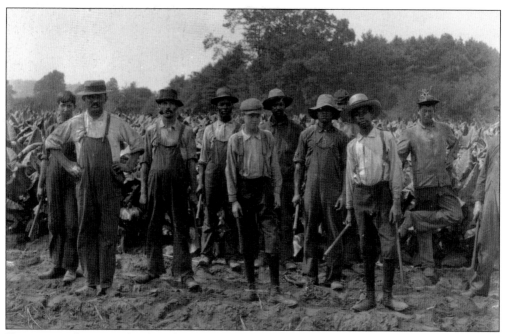

Harvesting tobacco was hard work and required many hands. The large stalks of dark green leaves were heavy, and the crop needed to be brought into the drying shed in a short period of time. The men working on the Barnes farm at 773 Palisado Avenue were holding their spear-pointed laths as they took a short break for the photographer.

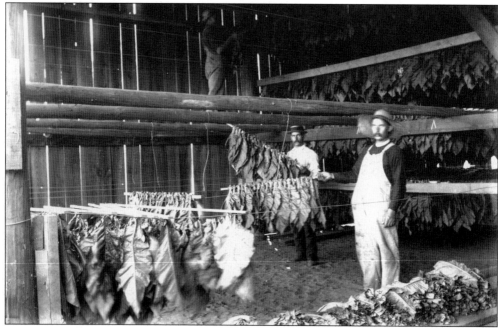

The tobacco sheds were packed tier by tier starting high up in the peak and working down. Men climbed up and straddled the high poles to hang the laths. A row of small fires helped to dry the leaves. Temperature and humidity in the sheds was regulated by opening and closing the vertical side slats or louvers. The leaves hung in the shed for eight weeks.

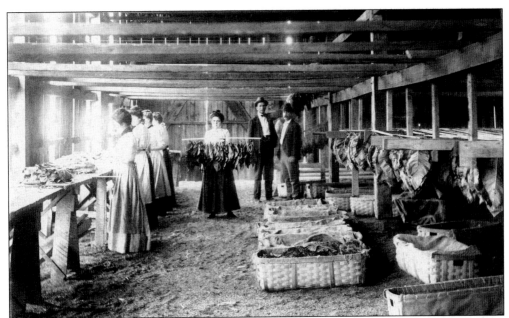

Young women often did much of the work in the tobacco sheds. After the leaves were dry, they were taken off the stems, checked carefully for holes, sorted by size, tied in small bundles, and packed in wooden boxes for storage. The P. Lorillard Company had a tobacco stemmery on Pierson Lane, and late in 1927, it bought the General Electric Company building on Mechanic Street for use as a warehouse.

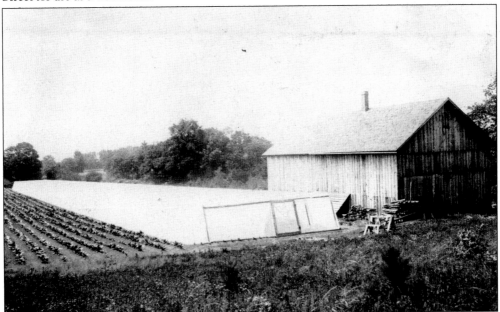

Today most of the tobacco grown in Windsor is the shade-grown variety. The first shade tents in the Connecticut River Valley were put up in Poquonock in 1900. The cheesecloth tents were erected to protect the tender plants, filter the sunlight, and increase the humidity, making the growing environment more like the plants' native Sumatra. Farmers planting shade tobacco took extra care at every step to produce perfect leaves for cigar wrappers.

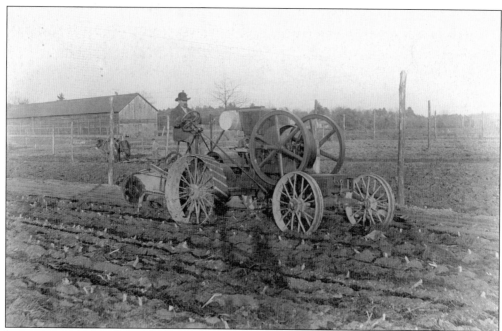

In late fall after the tobacco harvest was finished, the grower harrowed the fields. He turned the old stalks under and loosened the soil so it could absorb the winter moisture. The transition from horse-drawn to motorized vehicles took place during the 1920s and 1930s. Whatever the time period, extra-wide wheels were necessary in the muddy fields.

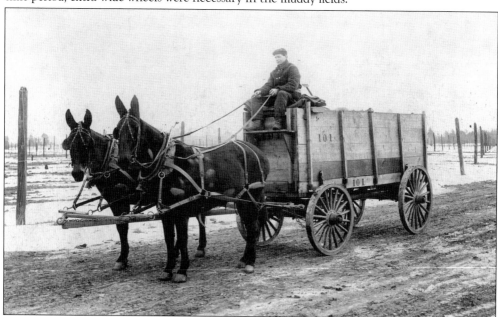

The snow-covered tobacco fields accentuate the skeletal nature of the wires and poles stripped bare of their cloth netting. Each season, new shade cloth was sewn to the wires. The posts were 10 feet tall and spaced 33 feet apart. Each square unit was called a bent. Laborers were paid by the bent for the work they performed. John Luddy of Windsor was one of the first to commercially distribute the cloth netting.

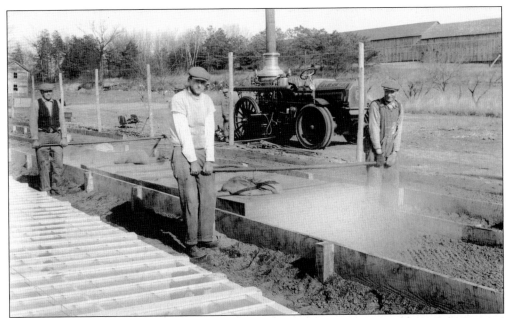

In early spring, a coal-fired boiler was used to generate steam to sterilize the soil in the seed beds. Once the minuscule tobacco seeds were planted, the beds were covered with glass panes to create a low greenhouse. The panels were opened to work the soil around the tiny seedlings. This photograph was taken at the Huntington Brothers farm in April 1933. (Courtesy Luddy/Taylor Tobacco Valley Museum.)

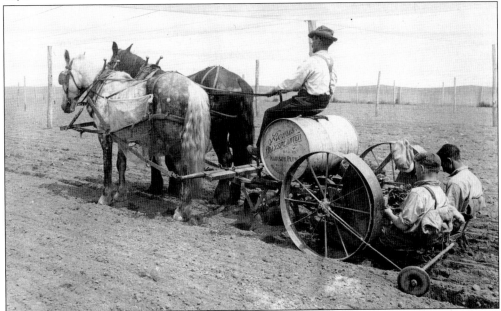

By late May, tobacco plants were large enough to transplant. The Bemis "setter" was an ingenious all-in-one apparatus. The two men planting wore a sack on their chests containing the tiny plants. A blade under the driver dug the furrow, the planters took turns placing a seedling into the groove, the water tank released a squirt of water, and a second disk blade resettled the dirt around the young plant. (Courtesy Luddy/Taylor Tobacco Valley Museum.)

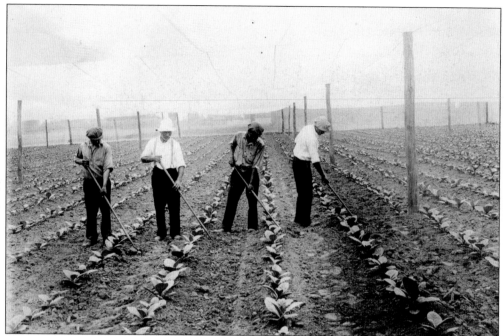

When the planting was completed, the men returned to the fields to weed the rows of seedlings. Women dusted every individual plant against cutworms and mold. Then each plant was tied with a string to the netting wires so it would stay upright. In eight weeks, the tobacco grew from six-inch seedlings to 10-foot-tall plants touching the tent cloth. (Courtesy Luddy/Taylor Tobacco Valley Museum.)

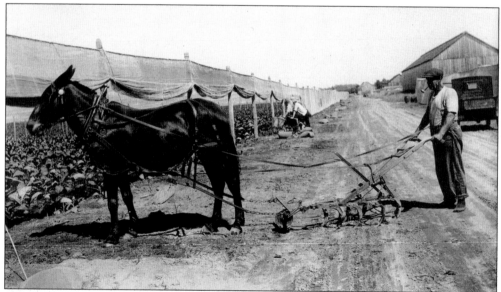

Cultivating and fertilizing were chores repeated all summer. Horses or mules were used to pull the cultivator until it could no longer be drawn through the field without damaging the leaves. Horse manure was considered the best fertilizer for tobacco until chemical fertilizers were introduced about 1900. The manure was shipped by barge up the Connecticut River from New York. (Courtesy Luddy/Taylor Tobacco Valley Museum.)

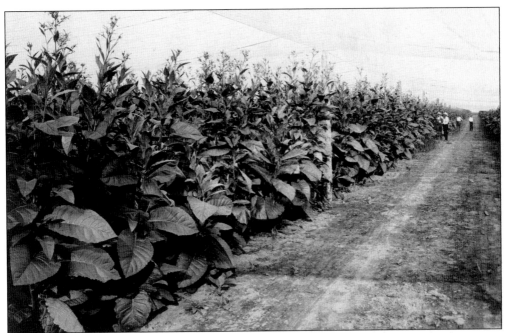

The tobacco plant produced a pretty, pale pink blossom, but the growers only allowed a few rows of plants to go to seed for the next year's crop. The rest of the plants were all "topped off" individually. The blossom stalk was snapped off so the plant would produce larger leaves. This field was part of the Huntington Brothers operation off Day Hill Road in about 1920.

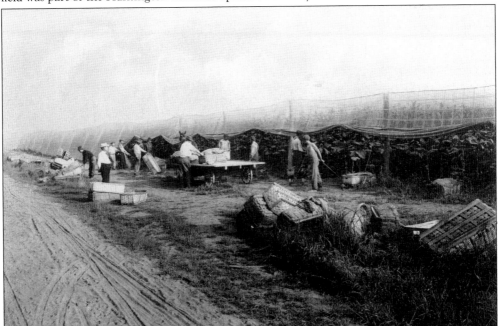

Shade tobacco leaves ripened individually and were picked three leaves at a time during July and August. The leaves were laid carefully in wicker baskets and the full baskets pulled out of the row by the dragger using an iron bar with a hook at its end. The heavy baskets were placed on a wagon and taken to the shed. The overseer in the white shirt supervised this important step.

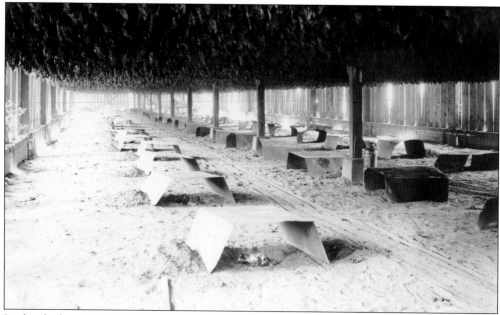

In the shed, sewing crews (usually women or children) selected pairs of leaves and strung them onto the lath. They wore leather palm guards to help push the needles through the tough leaves. Small charcoal fires were built in shallow depressions in the shed's dirt floor with metal shields to distribute the heat. Fires were tended constantly to ensure even curing of the valuable crop. (Courtesy Luddy/Taylor Tobacco Valley Museum.)

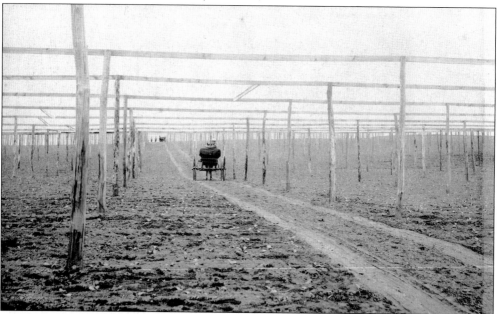

Broadleaf tobacco was frequently grown by small farmers alongside their other crops. With the introduction of shade-grown tobacco, the economics of the business and the appearance of the valley changed dramatically. The peak years of shade tobacco production were from 1900 to the 1950s. Although the use of tobacco products has declined in the United States, the crop is still a significant element in present-day Windsor's economy.

Three

INDUSTRY

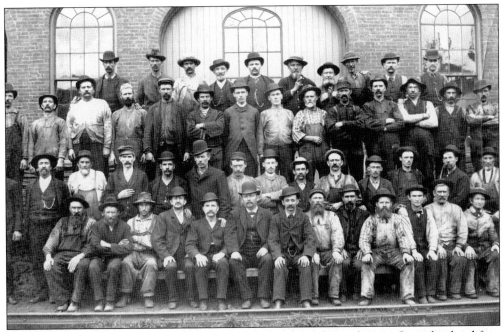

By the 1850s, New England was the seat of the Industrial Revolution. Great brick edifices utilized the Farmington River's power to manufacture paper, textiles, and later, electricity. There were more jobs than local workers could fill. Europe turned out its poor, and many came to Windsor. Irishmen working on the Windsor Locks canal found Windsor jobs when the canal was completed in the 1820s. Lithuanians found jobs in the mills and farms. These new citizens enriched Windsor with new religions, languages, customs, and foods. Pictured here are men by what may be the Eddy Electric Company in the center of town.

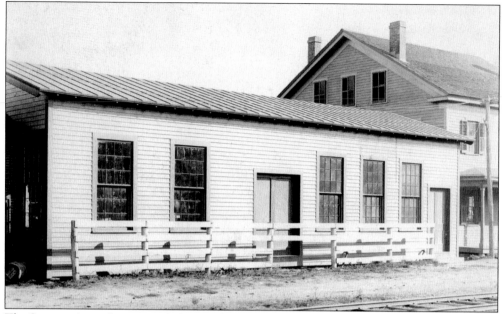

The Spencer Arms Company of 1883 was located in this Mechanic Street building. Christopher Miner Spencer's repeating shotgun was improved and manufactured here. He is famous for the repeating rifle used in the Civil War. The Confederate army said that "the Yankees loaded on Sunday for the rest of the week!" Spencer personally demonstrated his product for Pres. Abraham Lincoln, resulting in sales of over 200,000 rifles to the federal government.

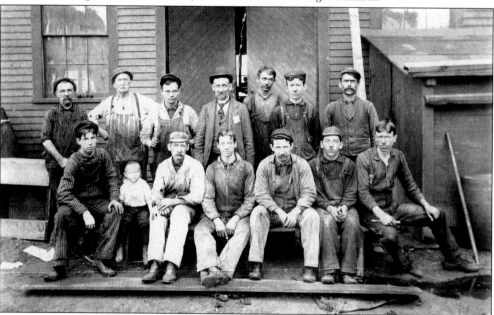

After selling the patent rights to the repeating rifle, Spencer went on to invent an automatic screw machine and a steam wagon or horseless carriage, seven of which were built in Windsor. When the railroads arrived in Windsor in the 1840s, Windsor's products were shipped nationwide. Here 13 mechanics and a child were photographed in front of Spencer's gun factory on Mechanic Street across from the railroad depot.

Spencer (1833–1922) was a Manchester native who worked for machine shops including the Colt Armory in Hartford. He married twice and had four children with his second wife, Georgette. They moved to a home on the corner of Orchard Road and Windsor Avenue in Windsor and then moved to Hartford in 1910. They are buried behind First Church in the Palisado Cemetery.

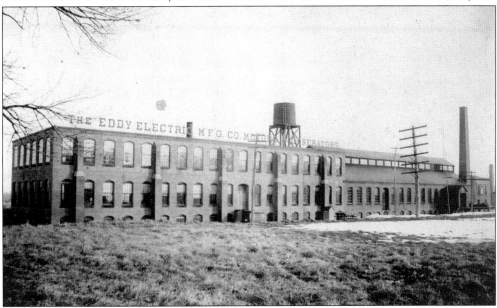

When the Spencer Arms Company no longer needed its building, the Eddy Electric Company moved in. The electroplating business was good, and in 1891, it built the large brick building known today, more than doubling its size. Nine years later the building and rights were sold to the General Electric Company. Starting in 1928, the building was used as a tobacco warehouse, and it was recently converted into condominiums.

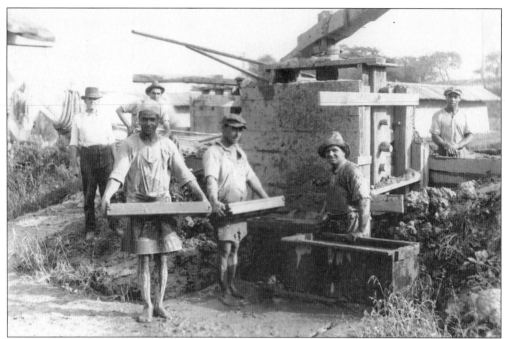

New mills and Hartford's insurance industry required large, fireproof buildings. Windsor's Mack Brick Company (1832–present) ably met this need. According to Dan Mack, bricks were an "elegant mixture" of three parts local clay, one part sand, and water as needed and blended together in a cragg. These men are holding wooden molds in which six bricks were shaped and then allowed to dry in the sun.

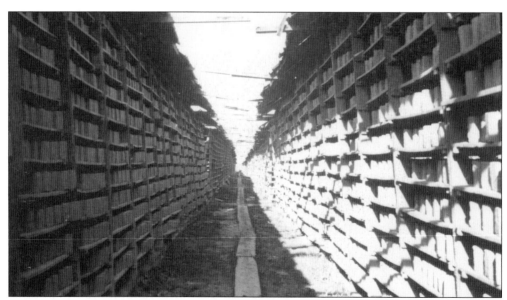

After blending, the clay was pressed into molds and inverted onto the ground where they lay drying in the sun. When hard enough to handle, the bricks were stacked in roofed sheds (shown here) to air dry before being placed in a kiln to be fired. These bricks were known as "water processed" and were much desired by architects for their consistent red color and durable surface.

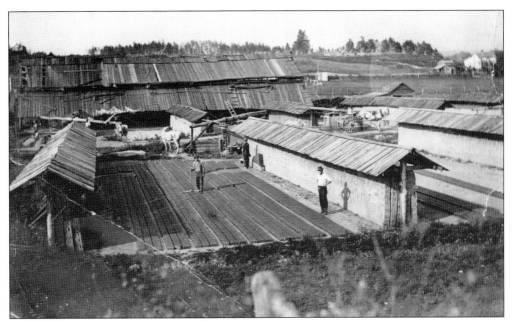

This overview shows bricks drying on the ground and stacked in roofed sheds before they were fired in a kiln. The white horse pulled the cart of clay while the horse in the center turned the shaft of the cragg. The roofs protected the newly set bricks from storms that could wash them away and destroy weeks of work. The hillside behind the sheds yielded the clay needed for brick making, and its contour is still visible on Mack Street

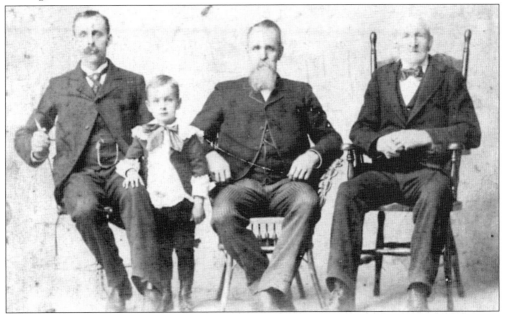

Four generations of the Mack family are pictured here with Edward Mack III (1923–2006) standing. The family descended from a Hessian soldier who fought for the British during the Revolutionary War. The family business started with a brickyard on Pleasant Street where bricks were easily loaded on scows and shipped to sites in Connecticut and Long Island. The business moved to Mack Street in 1846. (Courtesy Mack Brick Company and Edward W. Mack IV.)

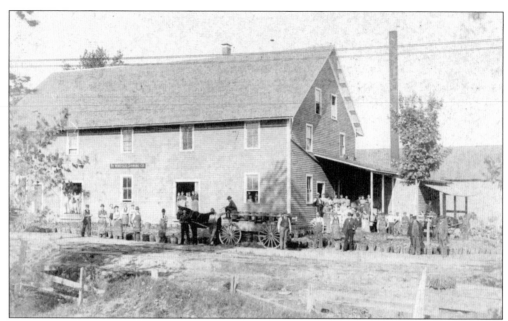

The broad, level fields along the Connecticut River helped make market gardening a profitable business in Windsor. Tomatoes in mid-summer and, later, apples and pumpkins were harvested and processed at the Windsor Canning Company located by the Mill Brook at 180 Poquonock Avenue. The company was operational from 1894 until 1953. The federal government was its biggest customer during both world wars.

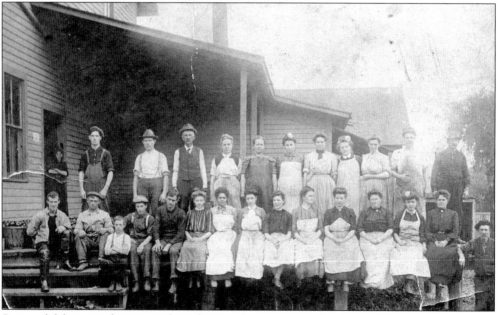

Seasonal labor cored, quartered, and canned tomatoes and other produce at the Windsor Canning Company. Women stood at thigh-high tables in aprons, their hair covered while they cored and sliced red tomatoes with small paring knives. A bare lightbulb illuminated their work area. Men ran the equipment to steam, seal, and label the cans. A warehouse stood behind this Poquonock Avenue cannery.

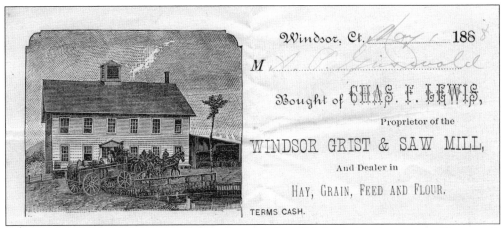

A gristmill was a necessity in any agrarian society such as Windsor's. On the corner of Poquonock Avenue and East Street, one of Connecticut's earliest 17th-century mills was constructed for the church minister John Warham. The present building was built as a gristmill in the mid-19th century and was powered by Mill Brook, which flows behind it.

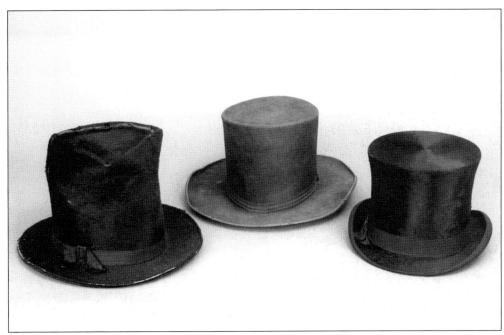

Another Windsor product was tall hats. William Shelton was a hatmaker on East and Pleasant Streets until his death around 1850. He used the imported skins of otter, beaver, and South American nutria to fill hat orders bound for Philadelphia and New England. His success enabled him to build his beautiful Pleasant Street home in 1830 using Mack bricks.

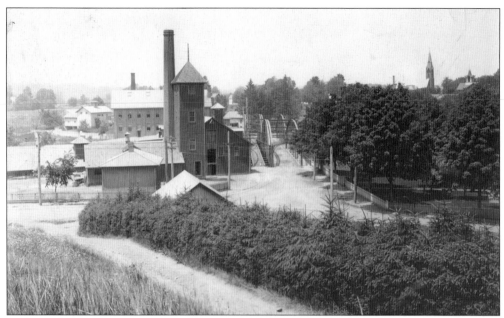

In the early-19th century, the agricultural village of Poquonock faced big changes as mills were constructed to harness the power of the swift-moving Farmington River that ran through town. There were sawmills and gristmills as well as mills for producing cotton batting, lamp wicks, toys, underwear, and twine. As Poquonock was exporting its goods, it was importing workers from Europe—Lithuanians and Irish included.

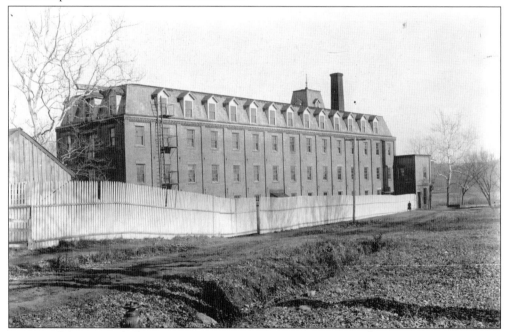

Over 300 laborers worked in Poquonock's mills in 1900. In 1848, with $26,000 in hand, John M. Niles started the Tunxis Company on the south bank of the Farmington River at the end of Tunxis Street. The mill manufactured cotton and woolen goods, and in the 1870s, switched to worsted yarns when Austin Dunham enlarged it. The building was razed in 1936.

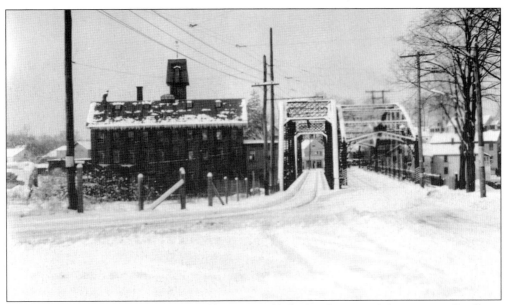

Small mills became larger, and new mills were established as Poquonock became a mill village. The trolleys connected Poquonock with the mill village of Rainbow to the north and Windsor's commercial center to the south. Automobiles and horse-drawn vehicles used the bridge on the right, while trolleys crossed on the left. Dunham Mill is pictured to the left of the bridges. It was razed in 1936.

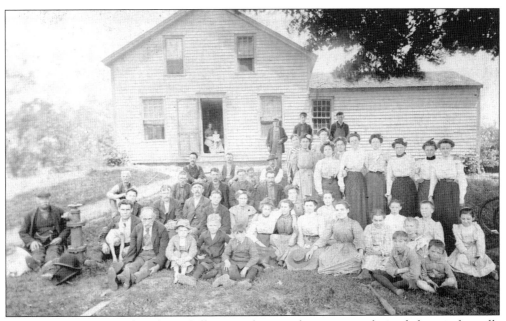

Mill wages were low, and workers of all ages and national origins were housed close to the mills in simple buildings such as this one on Tunxis Street. Young women could work in town rather than on the family farm. Notice the c. 1880 baseball bat on the ground by the young boys and the mother sitting with her baby in the doorway.

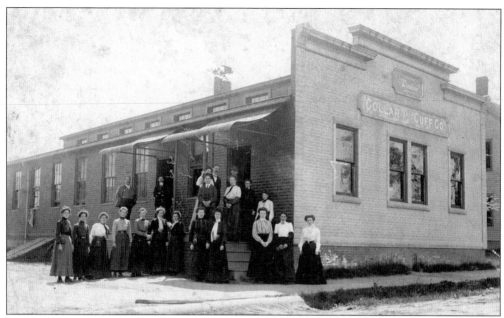

Smaller factories not dependent on the Farmington River's waterpower were situated in the center of Windsor. One example was the Windsor Collar and Cuff Company on Union Street. It made waterproof collars, cuffs, neckties, shirtfronts, and belts—all detachable and interchangeable garments. The company was in business until 1912, and then the building was converted to a laundry.

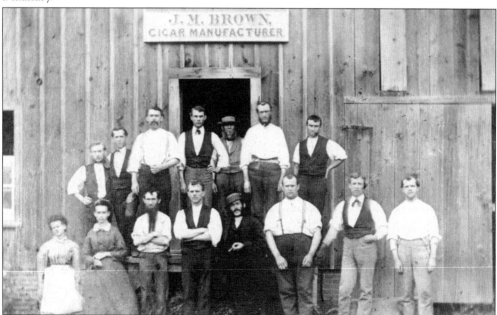

In 1901, James M. Brown started raising shade-grown tobacco on 20 acres behind Poquonock's town hall. Here the Brown family had a shed where cigars were rolled, cut to length, and boxed for sale in Hartford. Five generations later, the Brown family is still in the tobacco business despite volatile weather and developers' generous offers. Today they manage 500 acres of land. (Courtesy Brown and Martin families.)

Four

TRANSPORTATION

Windsor's earliest settlers used water as their primary means of transportation. The community's location at the intersection of two major rivers provided it with this natural advantage, but rivers also presented uncertainties and difficulties. Spring floods, strong currents, and significant distances to travel to Windsor's business and social community centers motivated residents to establish ferry crossings, improve their roadways, build bridges, and take advantage of public trolley and railroad service. At the beginning of the century, Windsor citizens enjoyed a wide variety of modes of transportation to meet their needs. Bissell Ferry is shown here. (Courtesy Julius Rusavage.)

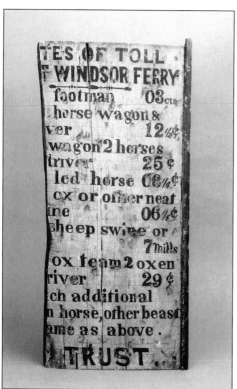

RATES OF TOLL
OF WINDSOR FERRY

footman 03cts
horse wagon &
driver 12½¢
wagon 2 horses
driver 25¢
led horse 06½¢
ox or other neat
one 06½¢
sheep swine or
 7 mills
ox team 2 oxen
driver 29¢
each additional
on horse, other beast
same as above.

IN TRUST.

In 1640, the Connecticut General Assembly awarded John Bissell the first contract to provide Connecticut River ferry service from Windsor to East Windsor Hill. Conveying the villagers' livestock back and forth to grazing lands on the east side of the river was one of the major duties of the early ferryman. Toll rates were determined by the Connecticut General Assembly, and a sign with the fares was posted on each riverbank.

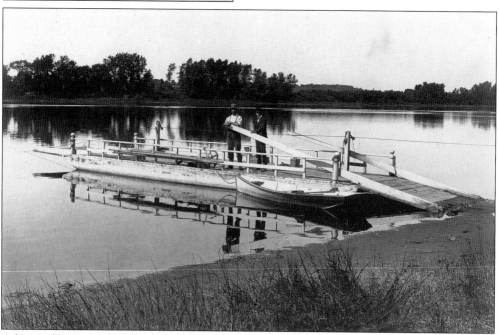

A long cable was attached to trees on each side of the river, running through a ring at the end of the boat to guide the ferry across the water. The 50-foot-long barge was powered across the river by the current. It was steered with a board angled along the side as a rudder. Another ferry crossed the Farmington River at the foot of North Meadow Road.

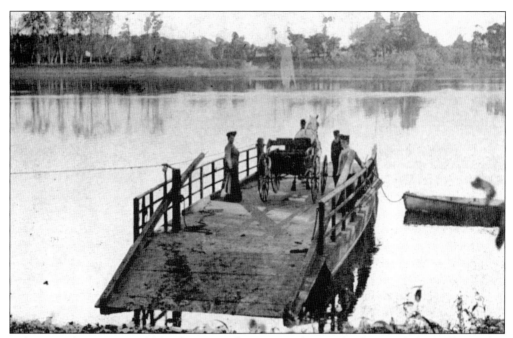

A horse and carriage could be driven up the ramp and onto the ferry and then off again on the other side. The Bissell Ferry was in continuous service until 1917. By the time it ceased operations, the Bulkeley Bridge in Hartford had been in use for nearly 10 years, and motor vehicle drivers preferred the bridge as a faster way to cross the Connecticut River.

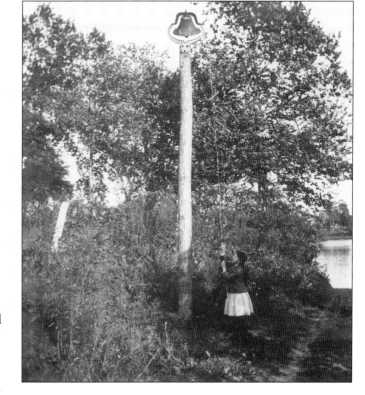

Most of the time, the ferry barge was kept on the east side of the river near the ferryman's house. This cast-iron bell was mounted on a pole on the Windsor side of the river at the ferry landing. If a customer on the west side wanted service, they pulled the bell rope to alert the ferryman. This bell is now in the collection of the Windsor Historical Society.

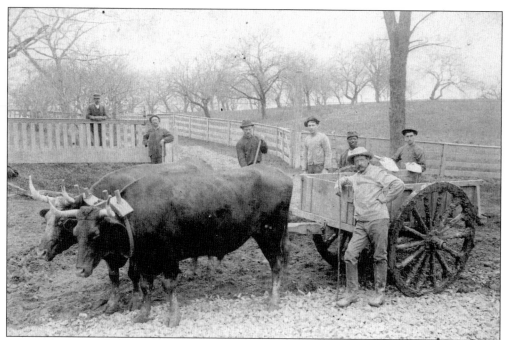

Increasing traffic on Windsor's dirt paths and lanes made them perpetually muddy or dusty. Road building was a perennial topic at town meetings, but it was not until the early part of the 20th century that significant improvements were made to meet the needs of the new automobiles. In 1892, Judge D. Ellsworth Phelps watched a crew work on the road in front of his house at 92 Deerfield Road.

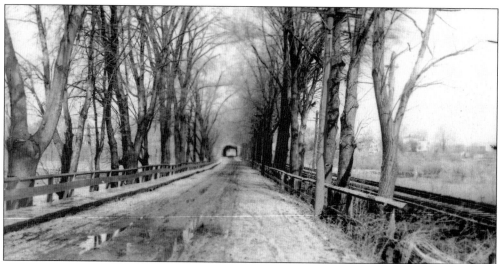

The first causeway and the bridge over the Farmington River were built in 1793 with funds raised by subscription and lottery. Bridges at this Palisado Avenue location were replaced several times due to destructive floods. This view of the causeway, looking north about 1910, shows trolley tracks on the right. In the distance, First Church is on the left and the Morgan house on North Meadow Road is on the right.

Milestones were set into the ground along major roadways to measure the distance to the county courthouse in Hartford (now known as the Old State House). A number of markers are still in existence today. This particular marker is in the collection of the Windsor Historical Society. Perhaps it was one of the stones installed by Herlehigh Haskell along the road from the Haydens neighborhood to Suffield in 1815.

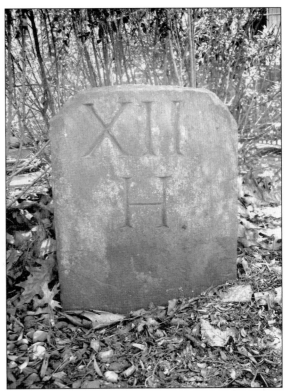

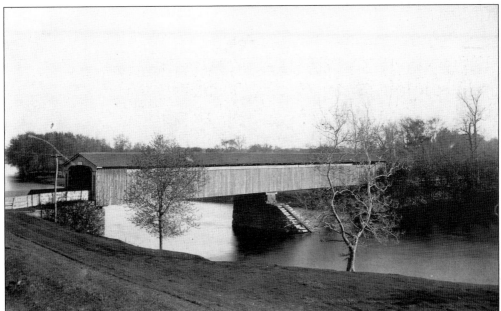

Windsor's third bridge over the Farmington River was called Fenton's Bridge. The truss bridge served the community from 1854 to 1916. This western view of the bridge was taken from the riverbank in front of First Church. Its springtime serenity belies the need for the stepped center abutments designed to break up ice floating downstream. Later this side of the bridge was painted with an advertisement for the Hartford clothier C. A. Rennacker (see page 22).

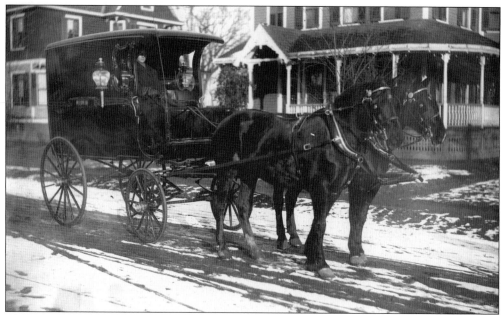

The use of horse-drawn vehicles reached its peak at the end of the 19th century. A wide variety of wagons and carriages, from simple carts to fancy enclosed cabs, were used for farmwork, transportation, and commercial purposes. This fine carriage belonged to James J. Merwin, a prominent undertaker in Windsor. The advent of the automobile during the early-20th century relegated the horse-and-buggy to history.

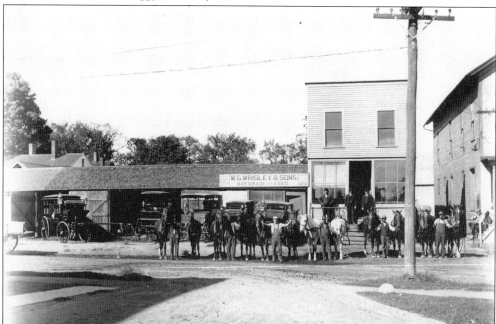

Wallace G. Wrisley ran a livery and trucking business out of this building near the railroad station on Central Street in the center of Windsor. He delivered coal, wood, lumber, fertilizer, ice, and other goods in bulk. Wrisley maintained stables with about two dozen horses and a variety of carriages and delivery wagons. Storage sheds for coal and lumber were nearby.

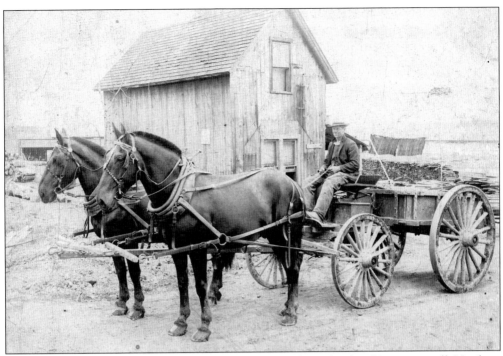

Martin Becker used his horse-drawn wagon to haul fresh-cut lumber from a sawmill. His farm was located on Matianuck Avenue in the Wilson area. Carts and carriages were made mostly of wood, with some iron parts such as the wheel rims. Leather was used for the straps and suspension, and paints and varnishes protected the wood surfaces. Even a small cart was valuable and needed to be cared for.

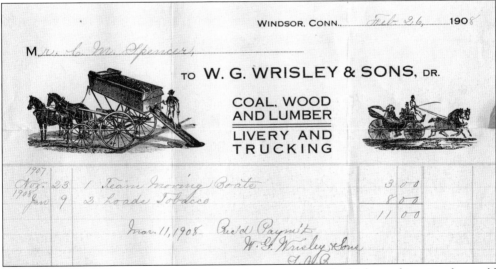

The masthead of Wrisley's receipt clearly depicts the range of vehicles and services he could provide. Coal was brought to Windsor by railway and then delivered to local homes and businesses. The wagon bed full of coal was jacked up and the load released down a chute into a coal bin. Perhaps one of the boats Wrisley moved for Christopher Miner Spencer was the *Luzette*, a craft Spencer built in 1885.

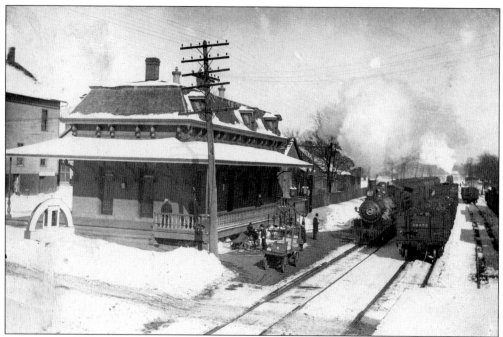

The railroad line from Hartford to Springfield through Windsor was opened in 1844. Windsor was now 12 minutes from Hartford and was directly connected to New York City and Boston. The Windsor station building on Central Street was built in 1869 and 1870 on land purchased from Ellsworth Phelps. The tiled mansard roof, dormers, and carved cornices were typical of mid-19th-century railroad architecture. The station was extensively renovated in the 1980s.

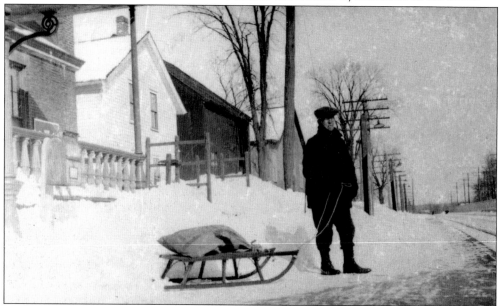

Trains moved large quantities of goods quickly and cheaply. Improved mail service was another advantage. Longtime Windsor resident Wilbur Reed is shown here with his loaded sled waiting at the depot for the daily train. For many years, Reed had the contract for carrying the mail sacks from the Windsor Post Office to and from the railroad station.

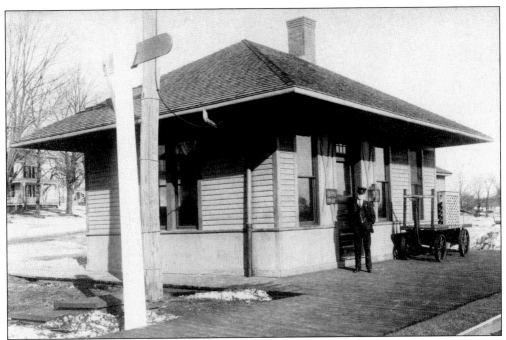

This little depot building served the neighborhood known as Haydens in the northern part of Windsor from 1904 to 1936. It was the second of three station buildings on Hayden Station Road just west of the railroad tracks on the line from New Haven to Springfield. Today this whole section of town is more commonly known as Hayden Station.

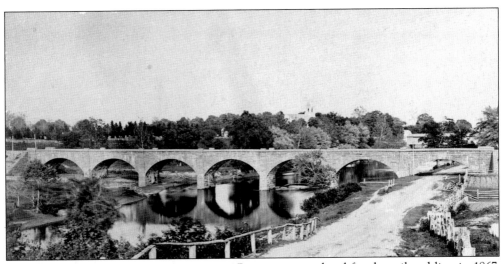

The sandstone bridge over the Farmington River was completed for the railroad line in 1867. Viewed from the west side, Pleasant Street meanders up to the southernmost arch at right. The Palisado Avenue covered bridge is visible farther east, and on the far hill First Church and the Palisado Cemetery can been seen. The bridge's symmetry and graceful arches have made it an enduring icon for many generations of Windsor residents.

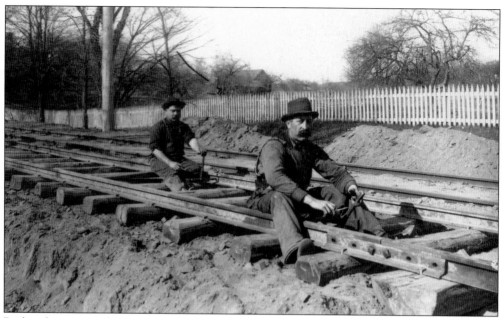

Railroads connected Windsor with the wider world, but the trolley car lines provided frequent and reliable public transportation within the region. The Hartford Street Railway Company provided service from Hartford to Springfield on both sides of the river. One trolley line paralleled Windsor and Palisado Avenues, while a spur ran to Poquonock. The tracks were laid in the 1890s, and the last day of service was April 13, 1940.

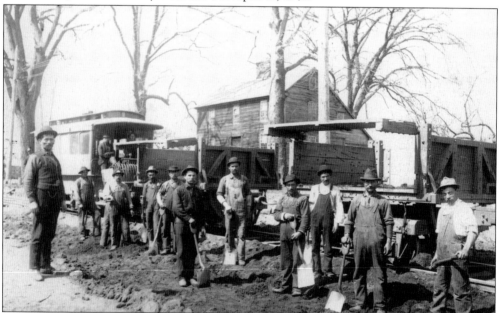

An enormous amount of manual labor was necessary to build and maintain the trolley tracks. Crews of Italian laborers were paid $1.25 a day to dig the roadbed trench two feet deep, fill it with broken stone, and then lay the ties and tracks. This pick-and-shovel crew photographed by the Howes Brothers was working on the trolley line near the intersection of Park and Windsor Avenues about 1894.

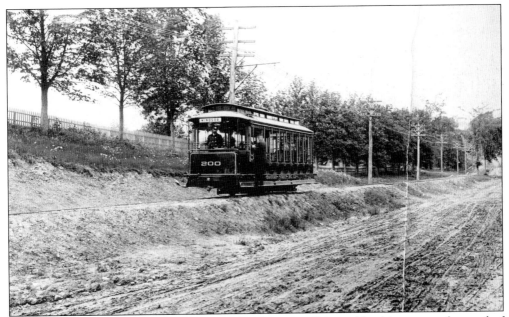

Although many roads were still unpaved, the electric trolley could achieve a steady speed of 20 miles per hour. The fare was 5¢ for a short ride. Station stops were spaced every quarter mile. Windsor had over 40 stops. Before house numbers were assigned around 1915, Windsor residents listed their address according to the number of their trolley stop. This Hartford Street Railway car is going up Stony Hill in 1895.

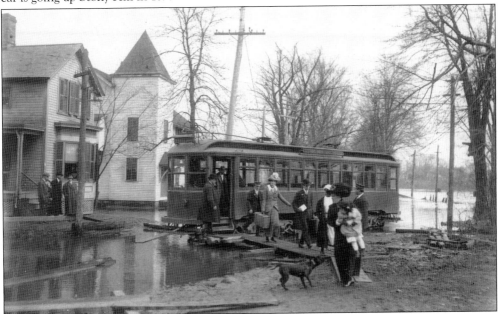

Recurrent flooding of the Farmington River created problems for the trolley lines as well as traditional modes of transportation. This trolley car was stranded on the south side of the river in front of the First Church chapel (now 15 Palisado Avenue). Its passengers, including women and children, crossed wooden planks to get from the car onto dry land. Later a dam was built upriver to help control the flooding.

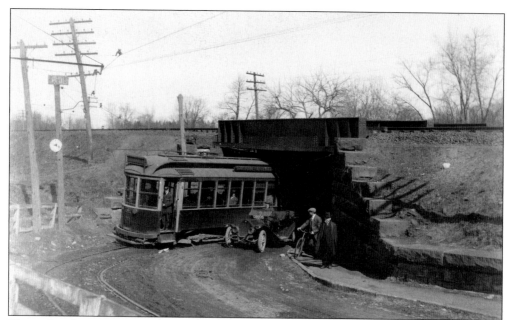

The railroad underpass on Broad Street was the scene of the convergence of several modes of transportation in November 1927. The trolley car and automobile competed for right of passage, and a bicyclist and a pedestrian came to view the damage. Although the roadway was straightened in 1916 when the "death trap" curve was eliminated, this underpass is still a difficult location for tall trucks.

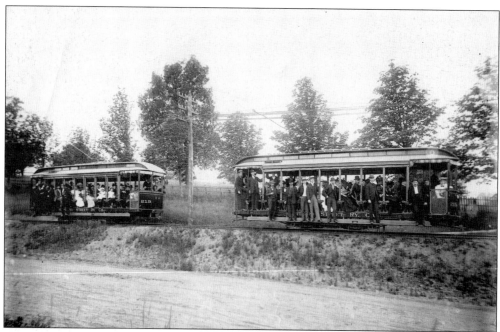

To promote business, trolley companies developed parks at the end of some of their lines. Rainbow Park in Poquonock competed with Luna Park in West Hartford, Piney Ridge in Rockville, and Lake Compounce in Bristol for visitors looking for a day of recreation. Here two trolley cars full of families were headed to Rainbow Park for a Sunday school picnic in the early 1900s.

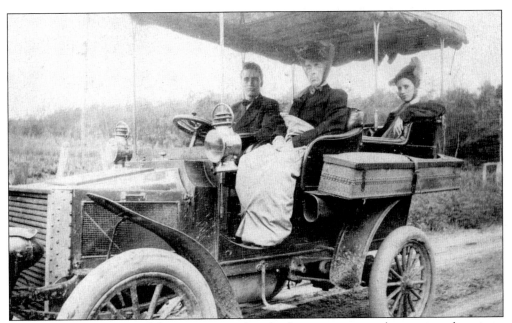

Inventors of early automobiles experimented with electric, steam, and gas-powered engines. Christopher Miner Spencer designed and built a steam-driven machine for his personal use. It had no bumpers, windshield, or solid roof and was described as "a buggy with the curtains rolled up." In 1906, some of his family took the car for a spin with Spencer's wife, Georgette, in the front seat and daughter Vesta in back.

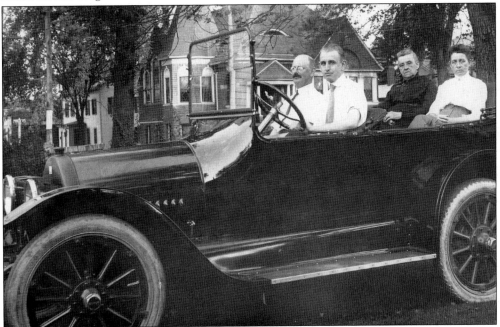

By 1920, the automobile had evolved into a vehicle with a lot of sophistication and style. Some models boasted of a windscreen, running boards, and a rumble seat. The Robert Barnes family posed in their car in front of their home across the street from the present Masonic lodge on Broad Street. Robert Barnes was a druggist in Windsor Center.

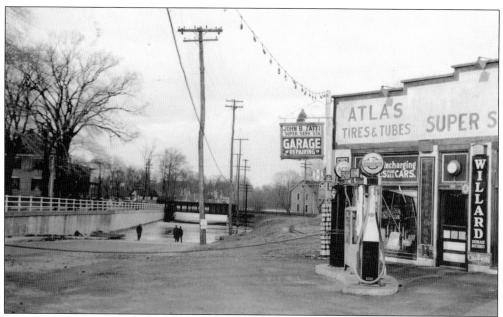

John B. Zatti's Super Service Station on Broad Street provided Esso gas and oil products to the burgeoning number of automobile owners in Windsor in the late 1920s and 1930s. Later Snow Buick took over the location, and currently the Aglow Building is on the site. In 1936, a rope was attached to the gas pump and strung across the road to stop traffic from driving into the flooded underpass.

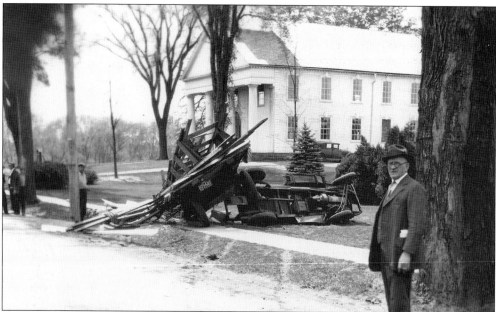

Constable Maurice Kennedy was in attendance at the scene of an automobile accident on Palisado Avenue in front of First Church sometime in the 1930s. The local newspapers frequently had stories of accidents caused by reckless driving. Few inventions have had such enthusiastic public acceptance as the automobile, but mishaps with trolleys, light poles, and pedestrians were common.

Five

VILLAGES

For many of Windsor's earliest years, haphazard paths connected farms and homes to woodlots and pastures, river crossings, water-powered gristmills and sawmills, taverns, and the church meetinghouse. After the Revolutionary War, a more formal pattern of roads was laid out. One main highway ran along the ridge of highland from Hartford north through Windsor Center, on to Springfield, and up the Connecticut River Valley. This is now Route 159, more familiarly known as Windsor Avenue, Broad Street, and Palisado Avenue. Another major road ran along the Farmington River to Poquonock and then west to Simsbury and New York State. Portions of this ancient road are now Poquonock Avenue and Route 75. Gradually little stores, district schools, and social halls were built near each other and formed discrete village centers. Each community had its own distinctive quality, but a common town meeting enabled the residents to maintain their identity with the larger town of Windsor. Today Rainbow, Poquonock, Hayden Station, Wilson, and Windsor Center still retain much of their village personalities.

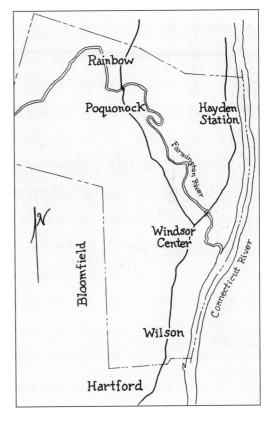

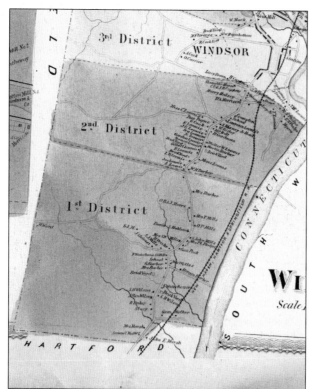

The southernmost portion of Windsor, extending from the Hartford city line north to Windsor Center, includes the communities of Wilson and Deerfield. Historically this area was primarily agricultural, but it also had a large number of brickyards. With the introduction of the trolley came the demand for suburban homes. By the 1920s, many new residents had moved north from Hartford, and Wilson began to take on a more built-up character.

In the mid-1800s, the Wilson family constructed a small railroad station on the New York, New Haven and Hartford rail line in order to ship their bricks to market. The railroad timetables designated the stop Wilson Station, and soon the village took on the name. This Wilson Station sign on a power pole beside the trolley tracks was located near the Wilson family homestead at 227 Windsor Avenue.

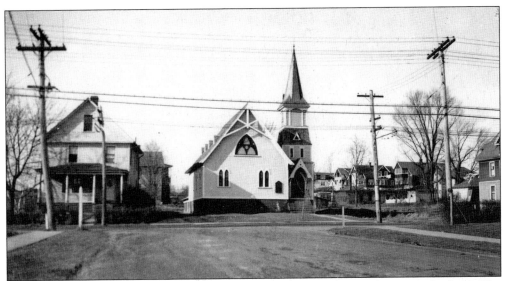

Wilson Station's compact village center included a general store, firehouse, and school. The first school had two classrooms downstairs and a meeting room upstairs for religious, moral, and political gatherings. This chapel (center) was moved from the village of Rainbow in 1900 to serve as the home of the Wilson Community Church. The building was bought, moved, and rebuilt for $2,000. The Leland P. Wilson branch library is now on this block.

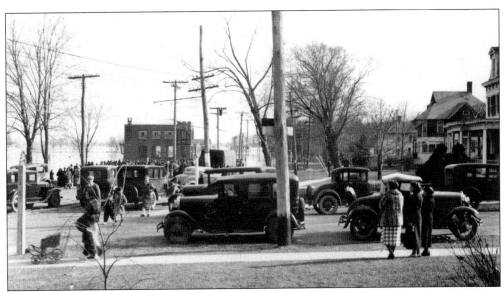

In 1936, many Wilson residents gathered at the lower end of Windsor Avenue to gaze at the surging Connecticut River floodwaters. The Wilson firehouse is the brick building left of center. The encroaching water surrounded the fire station and crossed the road and the trolley tracks but did not quite reach the Elijah Barber house at the far right. Many acres of farmland were inundated.

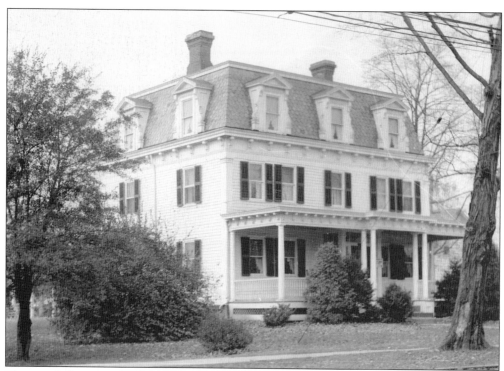

The stately home at 227 Windsor Avenue was built in 1790 by Elijah Barber, the father of Connecticut historian and artist John Warner Barber. Subsequently it was owned and occupied by members of the Wilson family for over 100 years. The mansard roof and front porch were added in 1878, giving the house a distinctly different look. For a number of years, it was operated as a tourist home.

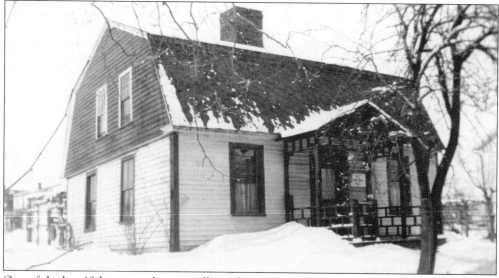

One of the last 18th-century houses still standing in Windsor, this gambrel-roofed dwelling was constructed in the same time period as the Barber house. Located at 195 Windsor Avenue, the house was built in 1787 by Lory Drake, a Revolutionary War veteran. He operated a sawmill along the stream now known as Keney Park Brook.

Henry Wilson began making bricks about 1812, and several generations of the Wilson family continued the business for nearly 100 years. Hundreds of thousands of Wilson bricks were used locally for houses, chimneys, and fireplaces. Long trains of oxcarts delivered loads of the bricks to the Mud-Mill wharf on the Connecticut River at the end of Barber Street. Other cartloads of bricks were taken to merchants in Hartford to be exchanged for groceries and other merchandise.

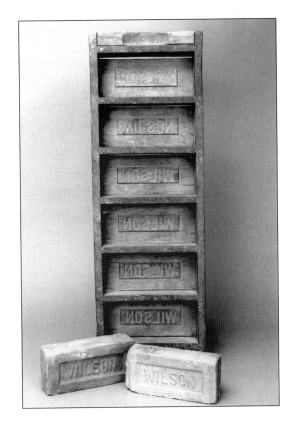

Wilson, Conn., _Oct. 20 1910_

M_r H Huntington Trustee H.S. Trisley Estate_

Bought of The Wilson Brick Co., Inc.

Successors to S. H. WILSON.

| Pallet Brick Manufacturers |

Bricks Delivered by Trolley 🙠 🙠 🙠 Daily Capacity, 90,000

1908

Nov 25 1000 f, Brick Windsor _8 50_

Samuel H. Wilson incorporated the family business as the Wilson Brick Company in 1878. He replaced the traditional handmade brick process with new machinery to make pressed bricks. The company was turning out over six million bricks per year by the time he retired in 1906. By then, the lumbering oxcarts had been replaced by trolleys, trucks, and railroad cars for delivering brick orders far and wide.

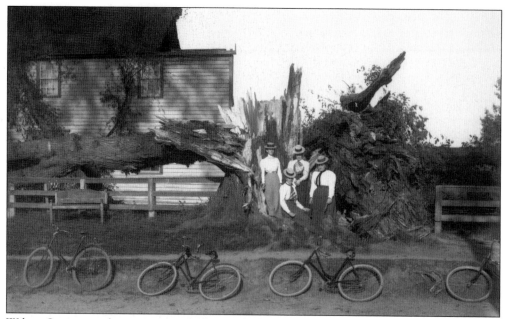

Wilson Station residents were justifiably proud of the gigantic elm tree that stood in the yard of the Eaton brothers' house on lower Windsor Avenue. The tree was over 80 feet tall and shaded an area 130 feet across. A violent thunderstorm in the summer of 1900 brought the tree down. These four young women rode their bicycles to see the destruction. Amazingly they all could stand within the hollow trunk of the enormous tree.

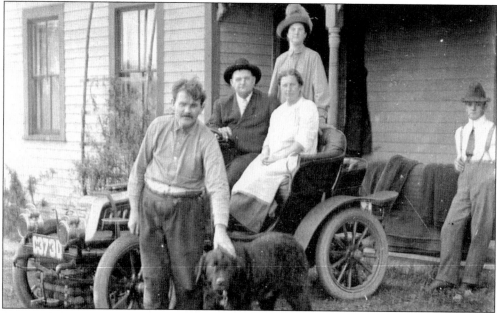

Louis Neher (standing at front center) lived on Wolcott Avenue in Wilson Station, a street formerly known as Pipe Swamp Road. His son-in-law Martin Becker was a market gardener in the Matianuck Avenue area. On the east side of Windsor Avenue, the Christensen brothers raised large quantities of vegetables for the Hartford market and the Hallgren brothers grew flowers, tomatoes, and bedding plants in extensive greenhouses.

Loomis, Phelps, and Mills are some of the earliest family names in the Wilson area. Oliver William Mills built the house at 148 Deerfield Road in 1824. The road in front of the house was thoroughly reconstructed 100 years later. Originally part of the old road from Hartford to Windsor Center, this turn in the road was too sharp for motor vehicles and became known as Dead Man's Curve.

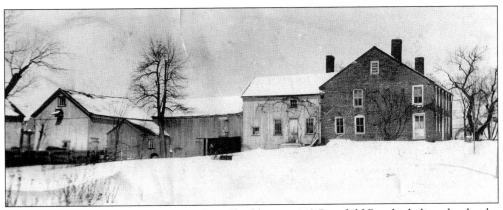

The house at the far right of this complex of buildings at 119 Deerfield Road is believed to be the oldest brick house in Windsor. Possibly built as early as 1670, it was originally constructed as a saltbox-style house with two stories in the front and one in the back. Portions of the house have brick walls 16 inches thick, enabling it to withstand centuries of time and weather.

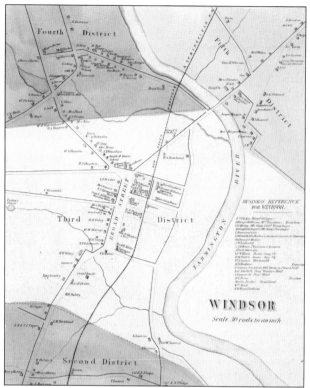

Nestled in a curve of the Farmington River, Windsor Center was the hub of well-traveled roadways before the coming of the railroad and trolley lines. Although many changes have taken place since this 1869 map was drawn, the familiar layout of streets and green is recognizable. The road from Hartford intersected with direct routes to Poquonock and Windsor Locks. The old road along the river wound through farmland and floodplains.

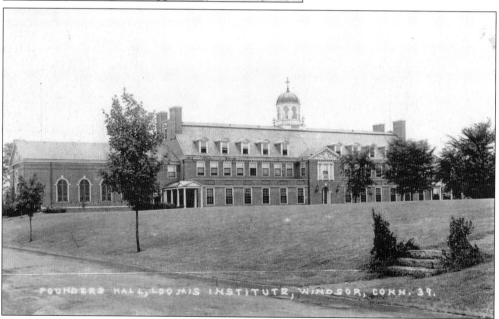

Crowds came to watch as the first steam shovel in Windsor took deep bites out of the soil of the island for the new Loomis Institute. The six buildings erected in time for the school's opening in September 1914 were a refectory, two dormitories, the powerhouse, a gymnasium, and headmaster Nathaniel Batchelder's house. The excess dirt was used to construct a 12-foot-high causeway for the road connecting the campus with Broad Street. Founders Hall opened in 1916.

This image of Broad Street convincingly demonstrates how much Windsor has changed in the last century. The trolley tracks crossed Creamery Brook and wound north toward Broad Street Green. The Oliver Mather house on the right is now home to the newly expanded Windsor Public Library. The property on the left is now a busy commercial area with Geissler's grocery store, a restaurant, and a hardware store.

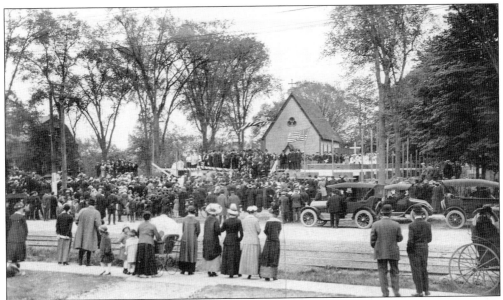

May 15, 1916, was a special day for the parishioners of St. Gabriel's Church. Hundreds of church members and guests gathered for a parade, dedication exercises, and a high mass. They were celebrating the end of a four-year, $35,000 effort to build a new church home. The new building at 379 Broad Street replaced the small chapel behind the viewing stand. The chapel was torn down in 1917.

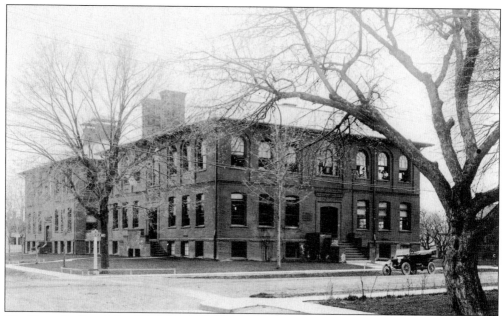

The Roger Ludlow School building on Bloomfield Avenue was built in 1894 for Windsor's high school students. It was named for 17th-century lawyer Roger Ludlow, who's Code of 1650 required families to teach their children to read, to know their catechism, and to learn a trade. When high school students here moved to the larger John Fitch High School in 1922, Roger Ludlow School became the center district's elementary school.

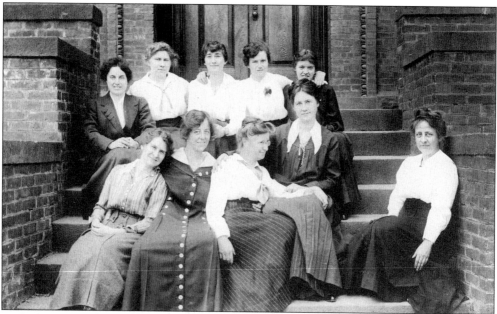

Each class at Roger Ludlow School traditionally had its group picture taken on these steps. This photograph of some of the faculty from about 1900 is more unusual. The young women may have received postsecondary teacher training at a state normal school, but they were usually required to give up their teaching career when they got married. Today the building is the home of St. Gabriel's Parochial School.

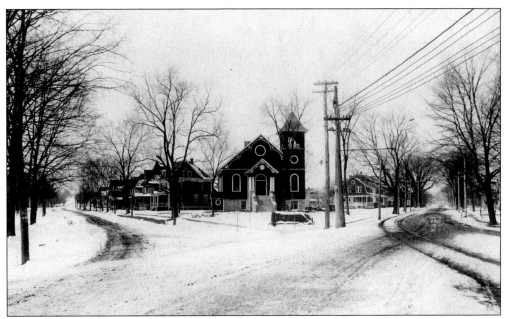

The Methodist Episcopal Church building at the intersection of Poquonock and Bloomfield Avenues was the congregation's second church home. Built in 1908, it was constructed of stone with shingled walls, a slate roof, electric lights, and steam heat. The sanctuary could seat 250. In 1961, the rapidly growing membership sold the property and built a new church on Park Avenue. The congregation is now known as Trinity United Methodist Church.

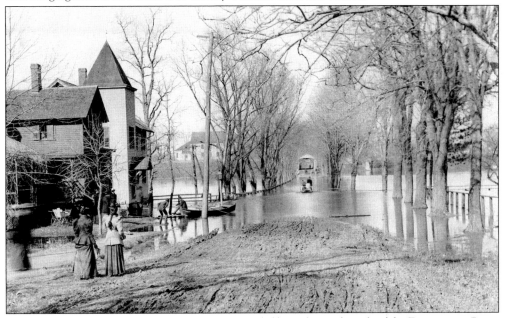

First Church in Windsor's vestry building (center, left) was located south of the Farmington River causeway just a short distance from the meetinghouse. The congregation used it as a chapel, for church school and prayer meetings, and for many social activities. On Sunday evenings the young people's Christian Endeavor Society, a nondenominational evangelical group, held its gatherings there. Today the building's address is 15 Palisado Avenue.

In the 18th and 19th centuries, the Palisado Green area was the commercial center of Windsor. Goods of all kinds were loaded and unloaded at the Farmington River landing. Jasper Morgan owned much of the property in this area and built this house at 76–78 Palisado Avenue around 1850. Alvin Fenton and later his daughter Hattie Fenton operated a general store in the house. They sold groceries and dry goods.

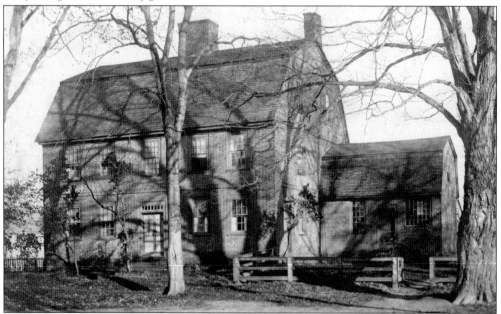

The Hezekiah Chaffee house at 108 Palisado Avenue has been a focal point of Palisado Green activity since about 1765. Chaffee and his son Hezekiah Chaffee Jr. were medical doctors. Another son, John Chaffee, managed the Hooker and Chaffee shipping firm in the 1790s. In 1926, the family sold the property to the Loomis Institute for its girls' school. Chaffee School merged with Loomis School in the 1970s.

The original Fifth District school building was built in 1707 on Palisado Green. It was moved up the road in 1827, and it burned in 1870. The replacement building at 235 Palisado Avenue featured elaborate Italianate details all fashioned in wood. Gen. William Pierson, a Civil War physician and Palisado Green neighbor, presented the new school with a bell to hang in its distinctive bell tower. Today Bell School is a private residence.

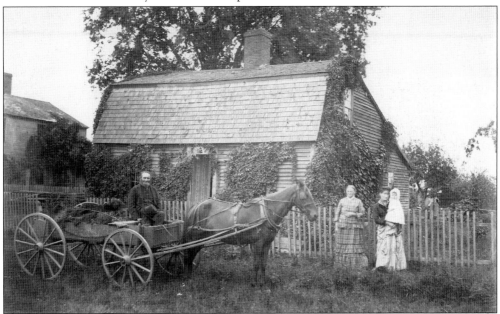

William S. Fish, his wife, Lucina, and daughter Addie lived in this historic saltbox house just north of Palisado Green during the latter half of the 19th century. In 1959, the Jewish Community of Greater Windsor purchased the property, razed the irreparably deteriorated house, and built the first Jewish synagogue in Windsor. Congregation Beth Ahm has now been at this 362 Palisado Avenue location for more than 60 years.

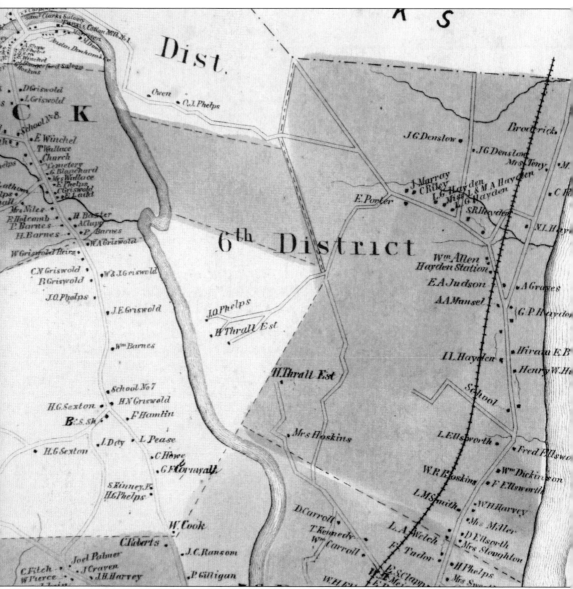

Hayden Station, Hayden town, and Haydens all appear on Windsor's maps through the years, telling that the Hayden family settled in the north end of the town in the early 1600s. William Hayden (died in 1669), the first Hayden to settle here, was a farmer and had a stone pit or quarry. A memorial boulder at Hayden Station Road and Route 159 was dedicated to him in 1885. In 1635, groups from Massachusetts arrived frequently looking for a place to establish farms or trade with the Native Americans. The area was hotly disputed between the Puritans of Dorchester, Massachusetts, and a party called the Lords and Gentlemen (also known as the Stiles Party), who had a patent for land from Rhode Island to the Pacific Ocean. In the end, the Dorchester group stayed near the Farmington River, while the Lords and Gentlemen moved north to the Hayden Station area. This 1869 map designates the area around the Hayden family homes as the Sixth School District. This is a farming community that turned to light industry in the mid-20th century.

Over the centuries, many Hayden families and their descendants lived along Pink Street. The street's name was changed to Hayden Station Road in 1935. Most Haydens were farmers, but Capt. Nathaniel Hayden (1738–1795) was also a tanner and made shoes. Hayden commanded the 23 men of the Lexington Alarm party in 1775 before continuing his career at West Point. His brick home was built in 1763, the year he married Anna Filer.

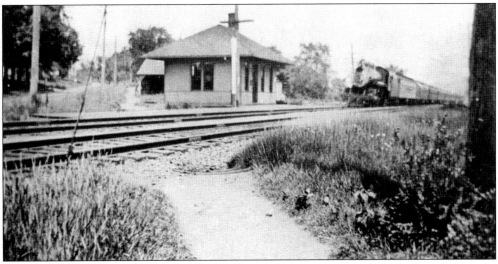

In 1844, the Boston-to-New York railroad ran through Hayden Station. Accessibility to train travel changed the village in subtle ways. Farmers' children could take jobs in nearby towns or go shopping in Hartford. Grace Clapp wrote that city friends were welcomed into the country homes of Hayden Station and soon "marriages outside of the old families frequently took place and so began a new social era." (Courtesy Julius Rusavage.)

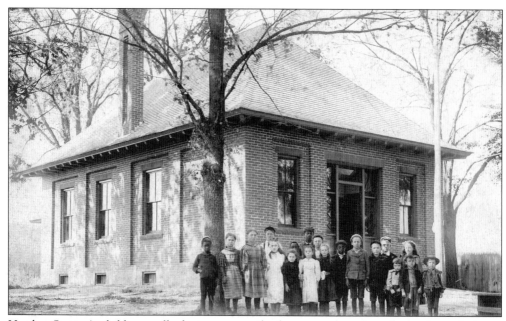

Hayden Station's children walked up to two miles between rows of maple, apple, and cherry trees to the one-room Hayden School constructed in the 1840s. Parents provided firewood for the wood-burning stove to warm the students and dry their snow-drenched garments. In 1896, the school burned and was replaced with the present building. Later students took the trolley or train to the schools in Windsor Center.

During the Revolutionary War era, free blacks began living in the area of Hayden Station and Pond Roads near a grove of pine trees where camp meetings were held. Sandy Archer, a former slave from South Carolina, donated the land needed to construct the Archer Memorial African Methodist Episcopal Zion Church on Hayden Station Road. He died in 1914 at the age of 108. (Courtesy William Best.)

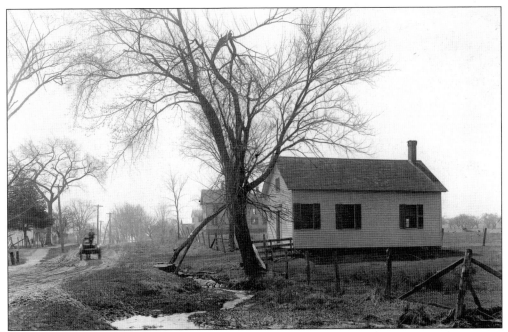

In 1876, the Union Chapel fulfilled the religious needs of the community with ministers from nearby larger churches as well as local ones. When trolleys began to carry parishioners to Windsor Center, the chapel was converted to other uses. It became the Hayden Station Social Club in 1887, with afternoon sewing groups, plays, fairs, and parties. It was supplanted with the hall, a larger building constructed in 1893 near the railroad crossing.

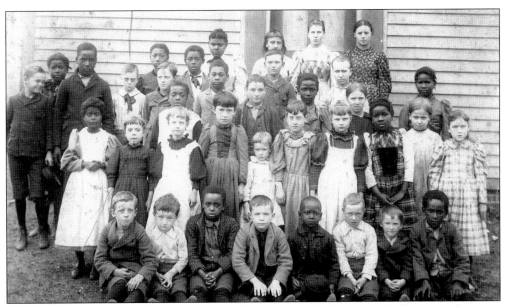

Theatricals, Christmas parties, and suppers of hot biscuits, chicken pie, baked beans, and pastries brought the neighborhood to the Hayden Station Social Club's doors. After serving as a chapel, the building was used as a Sunday school and as a library with storytelling hours for the children. These children were assembled for this 1894 photograph in front of the club.

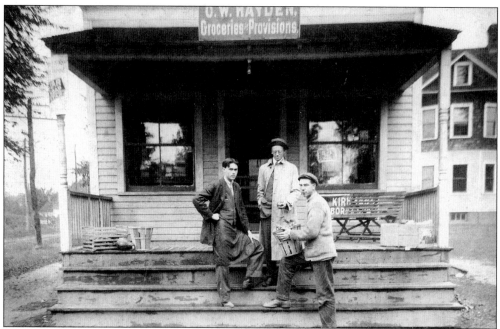

An enterprising Owen William Hayden (center) appeared in front of his small grocery store on Hayden Station Road. His store sold groceries and cigars. While delivering orders using a horse-drawn wagon in 1921, two bandits jumped out of the bushes, grabbed the horse's head and ordered Hayden to throw up his hands. Instead, as he whipped up his horse, the bandit shot his gun at Owen and missed. The bandits were not apprehended.

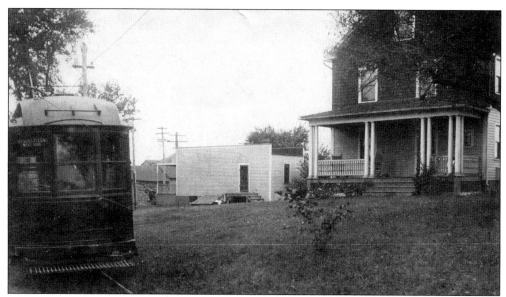

Trolleys changed the village by connecting locals to the city life of Hartford and Springfield. Items that residents did not grow in their gardens could be purchased weekly from peddlers, including extracts, yeast, tea, baked goods, meats, and the services of a traveling barber. Summers were filled with swimming in the pond, walks in the woods, and croquet parties. Pictured here is 90 Hayden Station Road, constructed in 1897, with a trolley in the foreground.

This is the Hayden Homestead, once referred to as "the hive" for its bustling activity. It was constructed in the 1730s on the site of William Hayden's first home lot and was lived in by Hayden descendants until 1912. This was the home of both farmers and merchants. When the house burned down in 1936, the cellar contained salt that was mined on Turks Island in the Caribbean Sea and brought on scows up the Connecticut River.

Pickett's Tavern once stood on this corner of Hayden Station Road and Center Street (veering right). Hayden Station Road was a section of the stagecoach route heading for Boston. After going through Hayden Station, the road began a flat, sandy stretch before it entered Suffield and points north like Springfield, Massachusetts. Militia training was held at the tavern, and it was a stop for pallbearers on their way south to Palisado Cemetery.

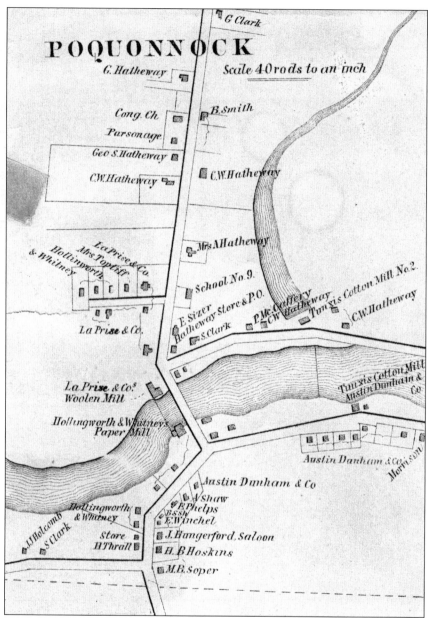

POQUONNOCK

G Clark

G. Hatheway

Scale 40 rods to an inch

B. Smith

Cong. Ch.
Parsonage
Geo S. Hatheway
C.W. Hatheway

C.W. Hatheway

Mrs A Hatheway

La Prise & Co.
Mrs Topliff
Hollinworth
& Whitney

School No. 9.

E. Sizer
Hatheway Store & P.O.
S. Clark

P. McCaffery
C.W. Hatheway
Tunxis Cotton Mill No. 2.

C.W. Hatheway

La Prise & Co.

La Prise & Co.'s
Woolen Mill

Tunxis Cotton Mill
Austin Dunham &
Co

Hollingworth & Whitney's
Paper Mill

Austin Dunham & Co. &
Morrison

A Holcomb
S Clark

Hollingworth
& Whitney

Austin Dunham & Co
A Shaw
E Phelps
B Sish
E Winchel
J. Hangerford, Saloon
H. B Hoskins
M.B. Soper

Store
H Thrall

Pronounced "Poe-quon-nock," this northern village takes its name from the Native Americans who lived here in the early 1600s. Translated, Poquonock indicates a battlefield or slaughter place. In 1649, families, including the Griswolds, Holcombs, and Marshalls, ventured away from the settlement and safety of the Palisado and headed north for new 20-acre home lots. They were in danger from hostile, distant Native Americans, so the town exempted one male homeowner to stay home and protect the community during militia training days. From that early and precarious start, this area became a community of farmers and then small-time textile manufacturers until larger factories were built in the 1800s. These factories harnessed the power of the Farmington River until the early 20th century, as evidenced by this 1869 map of the region. Today Route 75, Poquonock Avenue, is a residential street with 18th-century and modern homes, tobacco fields, and Northwest Park.

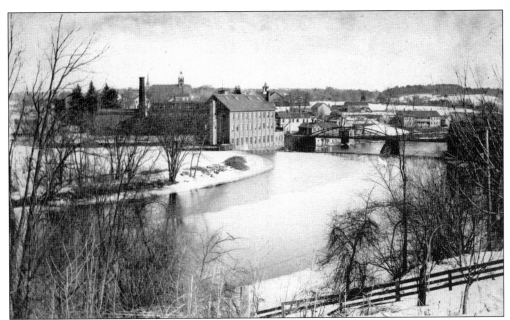

The Farmington River flows through Poquonock and was spanned by a steel-truss bridge in the early-20th century. The automobile and trolley bridge withstood the mighty spring floods, but flooding problems did spell the end of large-scale manufacturing along the riverbanks. Looking east, this c. 1894 image shows the Dunham Mills, a four-story brick textile factory. The steeple of St. Joseph's Church can be seen to its left.

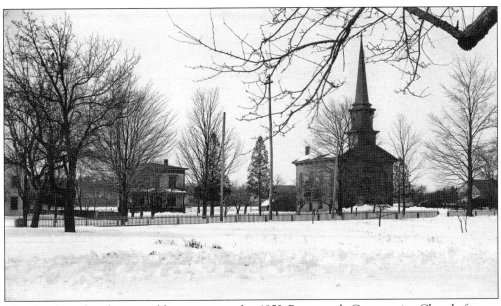

This lovely picket fence could not protect the 1853 Poquonock Community Church from a number of weather-related incidents that ultimately brought it down. A 1915 blizzard blew in its walls, roof, and chimneys. The steeple was blown over in the 1938 hurricane and replaced in 1959, but the entire church was later destroyed by the October 3, 1979, tornado. In 1981, the present building was completed. This 1930s image shows the church in happier times.

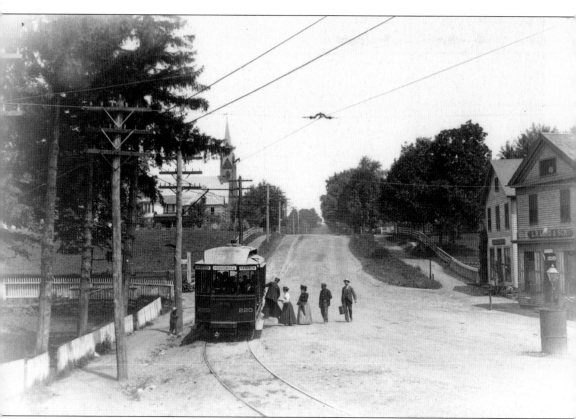

In 1895, trolleys started traveling from Windsor Center, through Poquonock, and on to Rainbow, taking people shopping and to their jobs. In this image of Poquonock Center looking north, a boy to the left of the trolley car has his ear against a power pole hoping to hear an approaching trolley. St. Joseph's Roman Catholic Church is at the top, while the L. R. Lord and Son country store is on the right beyond the horse trough. Lemuel Lord, a merchant, was a Civil War veteran who grew peaches and tobacco on his farm. (Courtesy Julius Rusavage.)

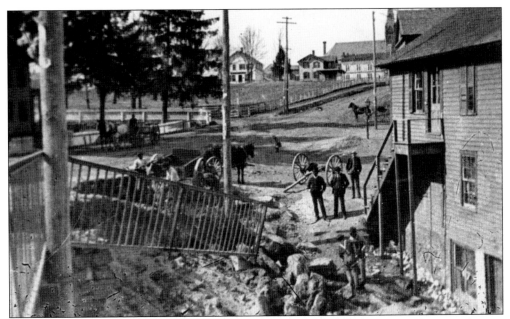

The Farmington River made livelihoods possible, but it could also devastate. This 81-mile river flooded with snowmelt almost yearly. Although the riverbanks were high, much erosive damage is evident in this 1895 image of Poquonock Center looking north. The building on the right is Charles Ende's barbershop. St. Joseph's Roman Catholic Church is visible in the distance. (Courtesy Julius Rusavage.)

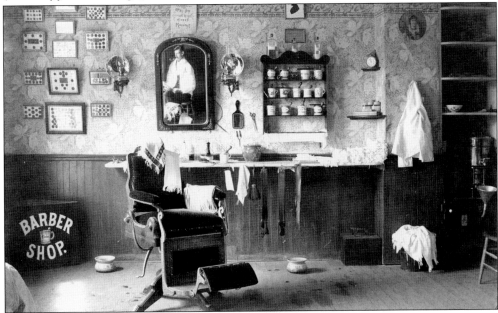

This image shows the interior of Charles Ende's barbershop, a convivial place for haircuts. Time could pass quickly as men caught up on news and events. Notice the coin collection on the wall and spittoons on the floor. Personal, individual shaving mugs were stored on an open shelf, and kerosene lanterns illuminated the room on dark days. (Courtesy David and Mary Lou Peters and Edward Endee.)

The Poquonock Town Hall stood where today's fire station is located at 1579 Poquonock Avenue. Constructed in 1882, it served as the town hall, community hall, and then as a firehouse until 1965. Village business was conducted here as well as much of the community's social life. The Grand Army of the Republic held its dinner dances here in 1888, as did the Windsor Business Men's Association in 1914.

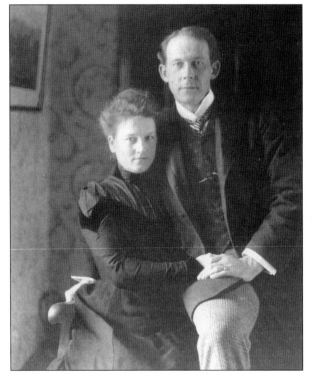

Emma and Robert Hatheway were early-20th-century benefactors in this working-class village. Married in 1898, Emma taught English to the Lithuanian newcomers and was the local librarian. Robert constructed shelving in a second-floor closet of the John M. Niles School for her card catalog. He was an artist and photographer and represented Windsor in the Connecticut General Assembly.

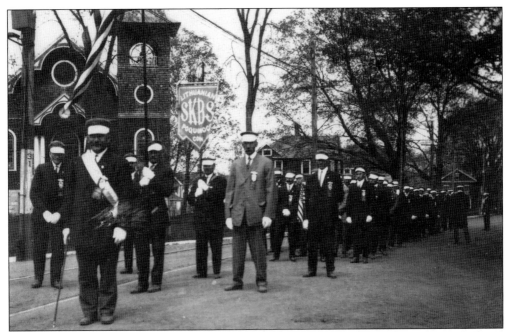

Lithuanians came to Poquonock from their Russian-occupied homeland to work in the mills and tobacco plantations in the late 1800s. By the 1930s, there were 13,000 Lithuanians in Connecticut. St. Casimir's Lithuanian Society was formed in 1910 and held meetings in the Poquonock Town Hall. This image shows Lithuanian marchers in a parade at the intersection of Poquonock and Bloomfield Avenues. The Methodist Episcopal Church appears in the background.

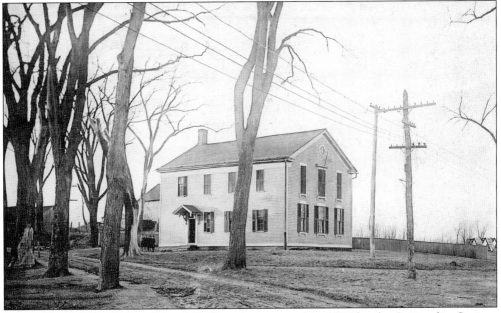

Located at 28 West Street, Liberal Hall was constructed in 1880 by the Spiritualist Society. This was a group that broke away from the Congregational Church but dissolved in the early 1900s. In 1940, the Lithuanian population in Windsor bought Liberal Hall for $475 and held its meetings, dinners, and celebrations in this building.

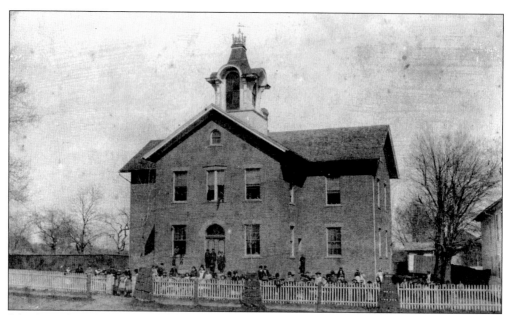

John M. Niles School was constructed in 1874 and was the third school built on this Poquonock Avenue site. It was named for John M. Niles, a founder of the *Hartford Times* newspaper in 1817, Hartford postmaster, abolitionist, and United States senator. In 1900, this brick school was attended by 99 students and was one of 19 schools in the town of Windsor. After serving as a library and commercial rental, it was razed in 1961.

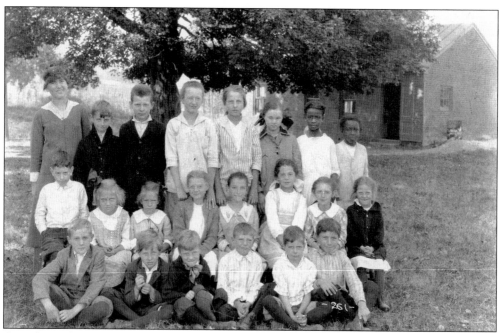

Once located at 826 Poquonock Avenue in the Seventh School District, the Thrall School was constructed in 1806 and was representative of a one-room country school. Pictured here in front of the small brick school in 1916 are 22 students of differing ages. The building was razed in the late 1900s to widen the Interstate 91 highway.

Christine Ladd Franklin, a grandniece of Niles, was born in 1847 at 1257 Poquonock Avenue. She went to Vassar College in 1869 and participated in its fourth commencement. She wanted to study physics, but laboratories were off limits to female students at the time. She switched to math, became a gifted mathematician, and was granted a fellowship at Johns Hopkins University, an all-male college at the time. In 1910, at the age of 63, she was a lecturer of logic and psychology at Columbia University. She married a young instructor, Fabian Franklin, in 1882 and died in 1930 having been called "the greatest logician since Aristotle." She received degrees from Vassar College (doctor of literature) and Johns Hopkins University (doctor of philosophy), which were given to her in 1926. When Franklin was 12, her mother died, but she grew up in a family that believed in women's rights. Franklin's supportive but dubious father was concerned that "excessive mental activity could jeopardize a young female's physical health."

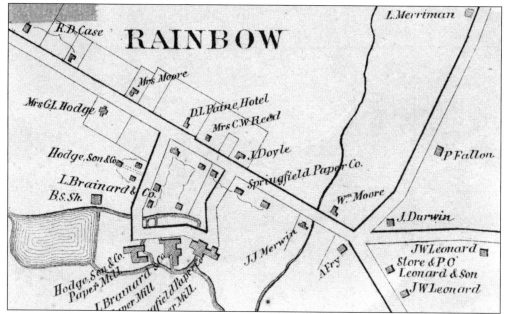

The Farmington River makes a graceful arc here, giving the village of Rainbow its name. Rainbow was a farming community in the northwest corner of Windsor until the early 1800s. At that time, the Griswold family constructed a small dam and mill, which were almost immediately swept away in a freshet. The idea of using the Farmington River's power here held fast, however, and by the mid-1800s, paper mills lined the north bank of the river.

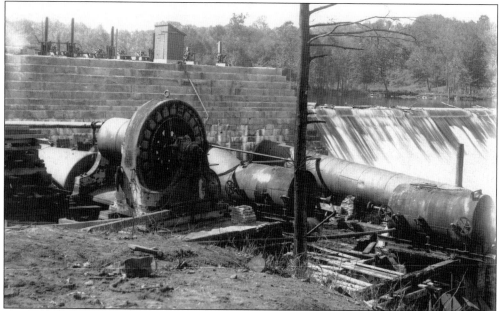

In 1889, Edward Terry (1850–1908) constructed a wooden dam at Rainbow just above this site. Electricity was transmitted 11 miles to the Hartford Electric Company power station, a first that proved to scientists that electric transmission over long distances for commercial use was possible. In 1925, the Stanley Works of New Britain acquired the property and constructed this new granite dam. The lake behind it stretched three and a half miles.

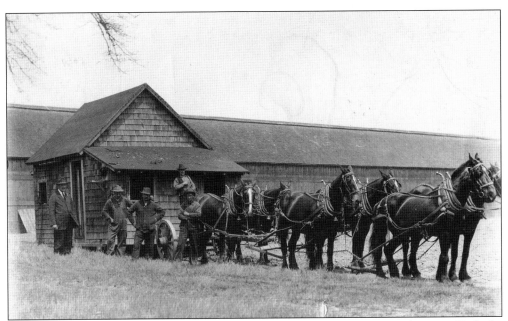

Fredus Case, living at 302 Rainbow Road in 1898, was a teamster and town selectman. He had a livery stable of 40 horses. He is pictured here with a team of six horses moving a small building where teamsters slept, known as the lobby, from his stables in Rainbow to a farm in Hayden Station. Holding the reins is Jimmy Case, who drove large teams for the Barnum and Bailey Circus for many years.

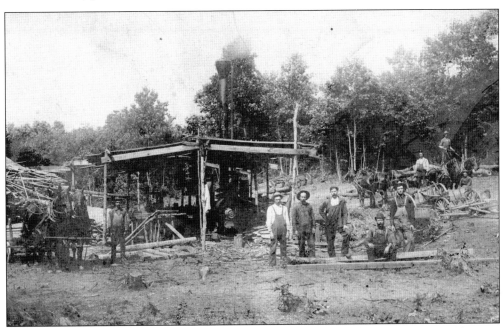

With the help of teams of horses from the Cases' stables, this portable sawmill proved a very useful aid in quickly clearing woodlots. The sawed wood was used for 19th-century mills, new housing, and the succession of Rainbow's dams. Seen here under a temporary shelter, this steam-powered sawmill could be moved to any site to saw felled trees into boards.

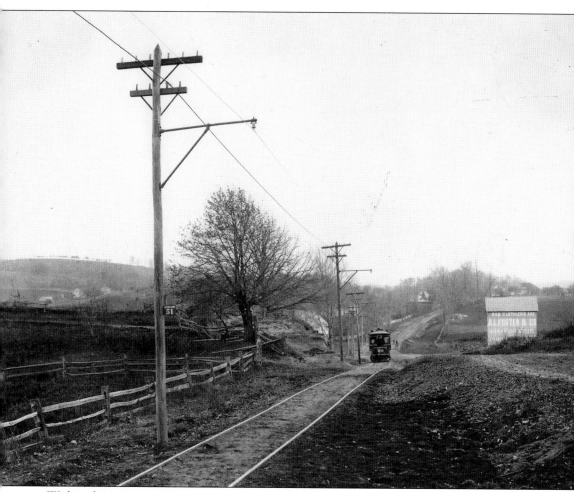

With industry came workers. Along Rainbow Road, worker housing, stores, a hotel, a school, and a Baptist church (later moved to the village of Wilson) sprang up. After long hours of hard labor, recreation was treasured. This trolley carried Hartford and Windsor residents to Rainbow Park, which opened in August 1895. Rainbow Park was a one-hour trolley ride from Hartford through the town of Windsor and across fields bordered with rail fences. The words "A. I. Foster and Co.," a Hartford department store accessible by trolley, appeared on the side of the barn at right. At Rainbow Park, one could spend the day outdoors, boating, picnicking, and dancing in the pavilion. Memories of this pleasure spot under the chestnut and maple trees where cool breezes were a promise sustained many workers through their long work weeks. The park was discontinued in the early 1920s, but the trolley line continued to carry machinery and supplies to the improved Rainbow Dam site in 1925.

Six

BROAD STREET GREEN

By the early-20th century, Broad Street Green was Windsor's commercial and social hub. Businesses, public buildings, and residences lined Broad Street, and trolleys, trains, wagons, carriages, and automobiles carried people and goods to and from the green. As proprietors of the Hotel Windsor, Owen Eagan (upper left), his wife, Margaret (upper right), and their two sons, Lawrence and Francis (front), watched the green grow and change in the early 1900s. The Eagans, pictured with their extended family around 1907, lived and worked on the green, boarded visitors and factory workers at the hotel, and ran a bar and dance hall in their establishment.

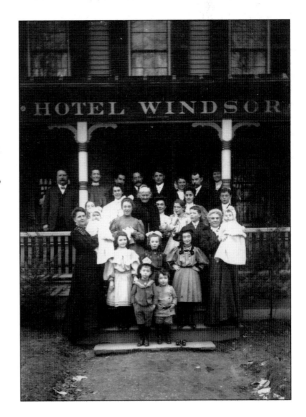

Broad Street Green was the site of many town celebrations, and its buildings were often decorated for these festivities. The residents of 296 Broad Street draped their home with patriotic bunting to commemorate the end of World War I on Armistice Day, November 11, 1918. Owned successively by the Clapp, Bryant, and Bissell families, the house stood on the site of the Windsor True Value Hardware store.

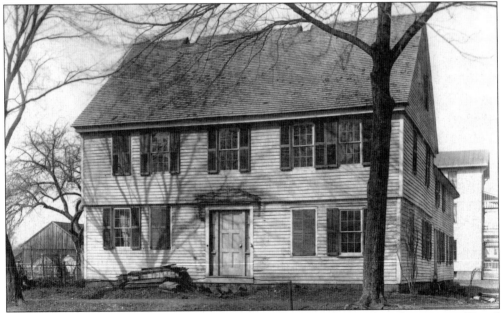

The William Loomis house was built in the 1790s and originally stood on the corner of Broad and Elm Streets, the current site of the Plaza building. Horace Clark moved the house to 31 Elm Street around 1897. The rear section of the building was once the 1690s Deacon Moore house. The Deacon Moore house was detached from the William Loomis house and given its own lot at 37 Elm Street.

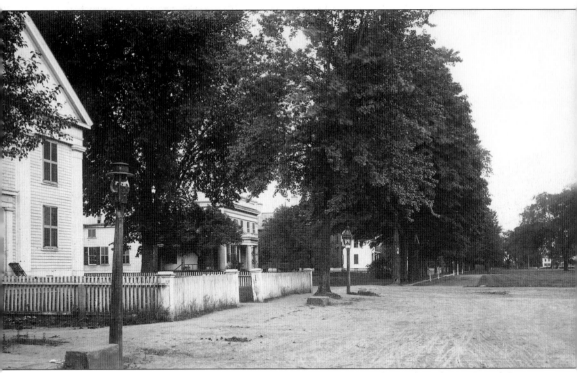

The land west of Broad Street was known as Bowfield during the Colonial era. Broad Street Green was known interchangeably as Bowfield Green until the early 1900s. In the 17th and 18th centuries, Bowfield was a farming community while Palisado Green, located north of the Farmington River on the site of the 1635 Dorchester settlement, was the town's commercial center. Large sailing ships from America, Europe, and the West Indies docked along the Farmington River, and their owners conducted business with merchants on Palisado Avenue. In 1810, Hartford built a bridge across the Connecticut River that blocked most ships from sailing north of Hartford and caused a steep decline in Windsor's shipping industry. In the 19th century, Windsor's center shifted south of the Farmington River and settled along Broad Street where businesses had easier access to Hartford's ports and railroads. By the 1850s, a railroad depot had been constructed on the east side of Broad Street, and churches, hotels, stores, and government buildings were built around Broad Street Green, making it Windsor's new town center.

This photograph shows Broad Street Green from its north end looking south in the late-19th century. Broad Street was originally a collection of farms, and its green was once grazing land. By 1900, the green was Windsor's social center, and the town's Village Improvement Society not only scorned animals on the green but encouraged pedestrians to stay on sidewalks and frowned upon wagons taking shortcuts across the grass. The society held dramas, fetes, and other fund-raisers to enhance the green's landscaping and to improve the roads and sidewalks that crisscrossed it. Businesses, churches, public buildings, and private residences enlivened the green and made it a gathering place for the town. Visible, from left to right, in these two photographs are the Methodist Church, the Hotel Windsor, the Col. Oliver Mather house, the Everett Hayden house, the old Windsor Town Hall, the Windsor Post Office, the Murphy commercial building, and the corner of the Col. James Loomis house.

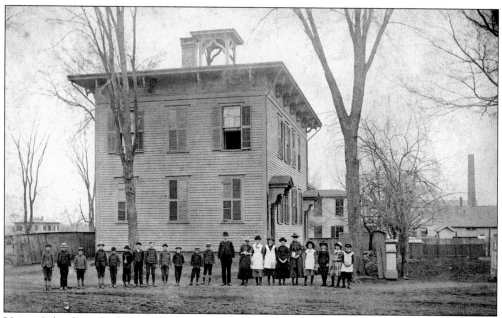

Union School was built in 1853 at 153 Broad Street, the current site of the Masonic temple. The school taught primary grades, and in 1877, its upper floors became a high school. First Church bought the property in 1894 and sold the building to Lawrence Mullaley in 1900. Mullaley moved it behind his Broad Street store where the school was eventually converted to commercial use. The building was razed in 1954.

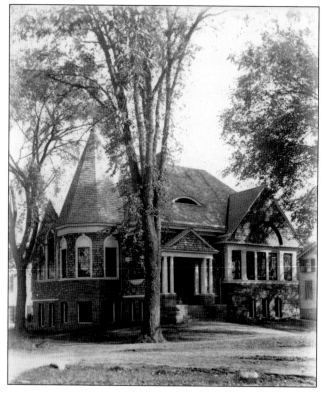

In 1902, First Church constructed a parish house at 153 Broad Street, the original site of the Union School. Built to accommodate "modern church life," the parish house had a kitchen, reading room, pastor's study, chapel, and several parlors for church gatherings. First Church sold the building to the Washington Lodge of Masons in 1955 and constructed a new parish house adjacent to its church on Palisado Avenue.

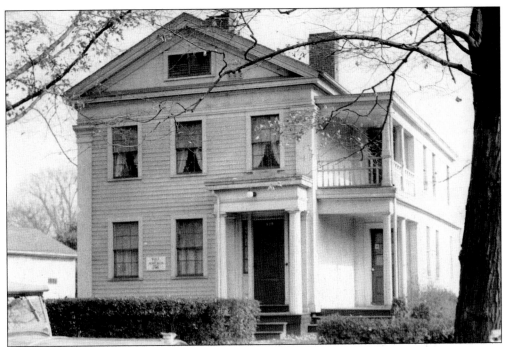

Although parts of the house at 175 Broad Street may date from 1789, its current facade was constructed in the 1840s. In the 19th century, the house was one of many private residences along the green, but by the end of the 20th century, most of those homes had been demolished or converted to commercial use. The house is now one of the last entirely residential houses on the green.

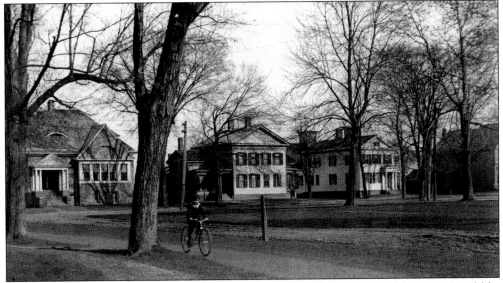

Historic homes, large trees, and grassy expanses gave the northeast corner of the green a parklike atmosphere in the early 1900s. By that time, middle-class Americans enjoyed substantial leisure time, giving many Windsor residents time for outdoor activities like bicycling, a popular Victorian hobby. The League of American Wheelmen became an early lobbyist for the pavement of dirt roads, an improvement that later benefited automobiles. (Courtesy Julius Rusavage.)

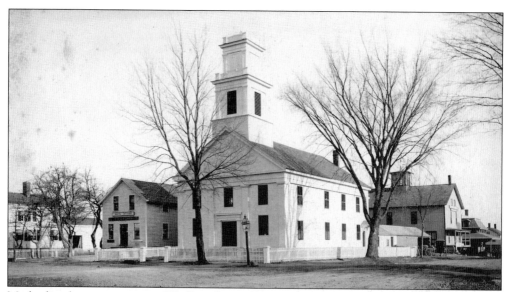

Methodists began meeting in Windsor during the 1790s and formally organized by 1809. They met in homes and schoolhouses before building a church on the corner of Broad and Central Streets in 1823. In 1907, the Methodists built a new church on the corner of Bloomfield and Poquonock Avenues. The original church bell moved with the congregation in 1907 and again in 1960 when the church moved to Park Avenue.

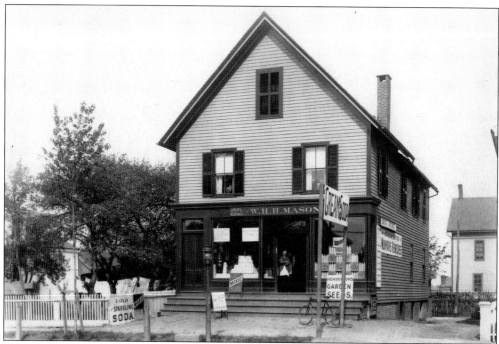

Windsor druggist William H. H. Mason ran a drugstore at 187 Broad Street, the current site of the Kernan Agency. In addition to pharmaceuticals, Mason sold candy, sodas, seeds, detergents, and other household goods. Fire destroyed Mason's original store in 1896, and he rebuilt on the same site. In 1907, Mason purchased and razed the Methodist Church next to his store to construct a large commercial building.

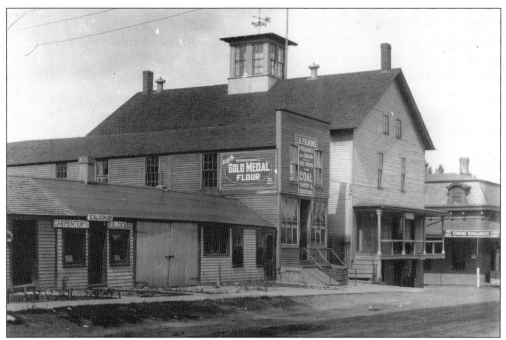

Windsor Center was a stop on the New York, New Haven, and Hartford Railroad, and Central Street was a commercial byway linking the depot with Broad Street Green. The Best Manufacturing Company produced cigars in a building next to the depot at 39 Central Street (second building from the right). In the early 20th century, E. Bloomer ran his carpentry business from Wrisley's former livery stable at 25 Central Street (far left).

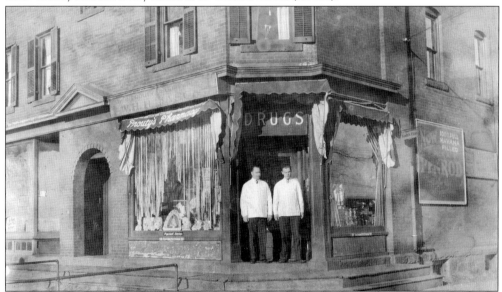

In 1907, Mason purchased the Methodist Church building for $6,000 when its congregation moved to the corner of Bloomfield and Poquonock Avenues. He razed the church and constructed a three-story brick commercial building containing two storefronts and four apartments. He moved his drugstore to the new building in 1908. Edward Prouty took over the store after Mason's death in 1921.

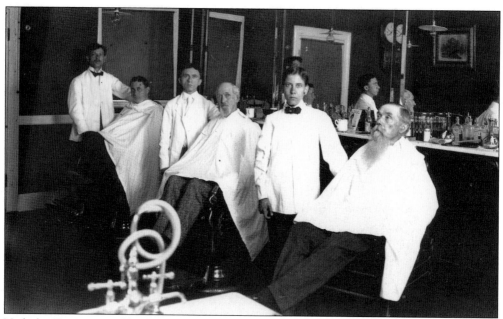

Nicholas Triano moved his barbershop from Central Street to the new Mason building in 1908. Proud to run a thoroughly modern shop, Triano and his assistants wore their hair parted slightly to one side, a very modern style. Triano's oldest clients still sported untidy beards fashionable in the 1880s, while his younger clients preferred the short beards or clean-shaven faces popular in the early 1900s.

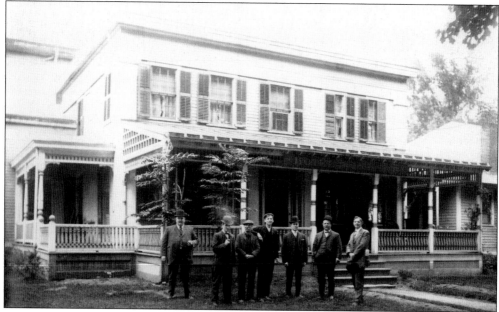

In the 1800s, the Hotel Windsor was also known as the Alford House for its early owner, Elijah Alford. George G. Sill's family ran the hotel at 219 Broad Street from 1837 to 1877. As Connecticut's lieutenant governor, Sill was often absent and outsourced the hotel's operations. Owen Eagan (second from right) bought the hotel around 1890 and personally ran its guest rooms, bar, and dance hall until his death in 1932.

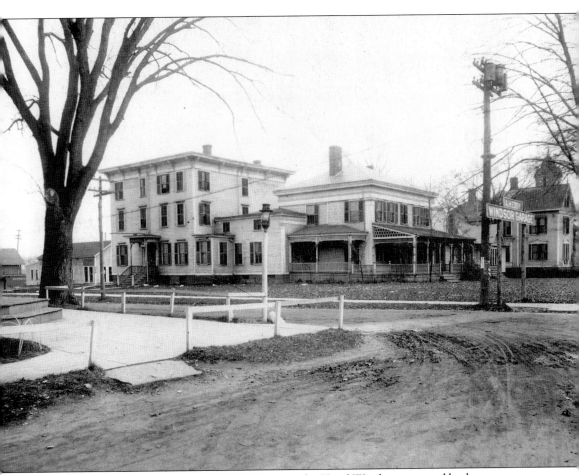

Located at the corner of Broad and Central Streets, the Hotel Windsor attracted both passengers disembarking from the railroad and Windsor residents doing business on the green. The Sill family built a three-story addition to the hotel in 1870, and Eagan built the Windsor Casino, a dance hall, on the property's south side around 1900. In the 1920s and 1930s, the casino also housed the town post office, a lunchroom, and the offices of the *Windsor Herald* newspaper and the Capitol City Lumber Company. Prohibition closed the hotel's bar between 1920 and 1933, and business declined so dramatically that Eagan was forced to temporarily close the entire hotel. He remodeled the hotel's guest rooms in order to improve business and reopened 25 rooms in 1926. After Eagan's death, the building passed through several owners. In 1957, James Tasillo bought the property and connected the hotel and dance hall. In the 1960s, the building became the Windsor House Restaurant, and later, the Windsor Tavern. In 1998, the building was razed and a CVS Pharmacy was erected on the site.

In 1901, Euphemia Loomis established a trust for the construction of a public fountain in memory of her husband, Hezekiah Bradley Loomis, a founder of the Loomis Institute, now the Loomis Chaffee School. Completed in 1903, the Loomis Fountain sits at the center of the green across from the town hall. In 1983, the Windsor Exchange Club renovated and rededicated the fountain for the town's 350th anniversary.

A fire swept through Windsor Center in 1869, destroying a row of buildings along eastern Broad Street. In their place rose several stately homes, including Horace Tudor White's grand Victorian house at 241 Broad Street. Built around 1882, the house was designed in the Queen Anne style famous for towers, porches, bay windows, and dramatic ornamentation. The house was demolished in 1963 during the construction of the current post office.

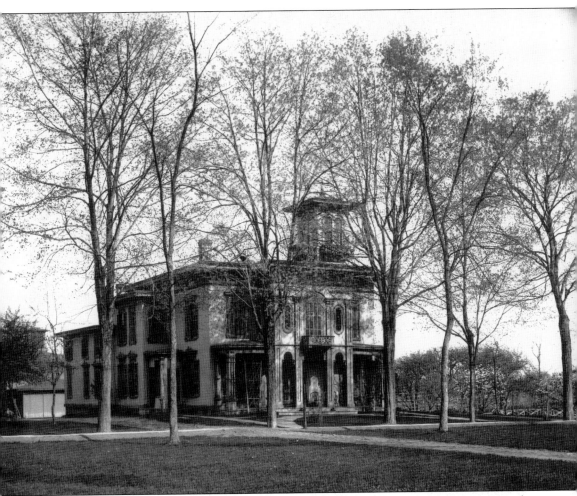

Hezekiah Sidney Hayden was one of Windsor's most prominent 19th-century businessmen and landowners. As a young man, Hayden left Windsor to run his brother's jewelry and silver goods company in Charleston, South Carolina. He returned to Windsor in 1858 and lived with his wife, Abigail Loomis Hayden, at 275 Broad Street. In addition to serving in the town and state governments, Hayden was a probate judge, a trustee of the Loomis Institute, the founder of the Young Ladies' Institute, and an organizer of the Windsor Water Company. He contributed to the construction of the Grace Episcopal Church and the reorganization of the Windsor Fire Company. He was also one of the largest landholders on Broad Street Green, having inherited much of the land from his father-in-law, Col. James Loomis. Over several decades, Hayden sold many commercial and residential lots around the green. He died in 1896, and his ornate mansion was razed in the 20th century. Today Windsor's town hall stands on the site.

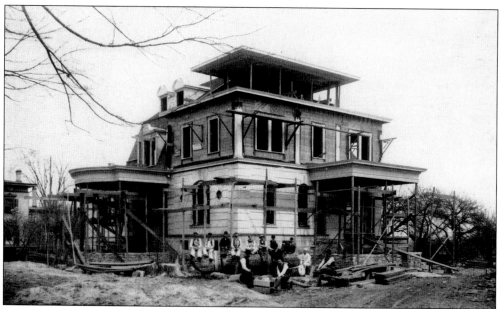

In 1901, Henry and Mary Huntington purchased land from Hezekiah Sidney Hayden's estate to build their home at 289 Broad Street. A mixture of classical columns and asymmetrical porches and balconies, the new house had a unique style that distinguished it from its Victorian and Colonial neighbors. The Huntington's attention to detail continued inside where the decor included the finest wallpapers, built-in cabinetry, and stained-glass windows available at the time.

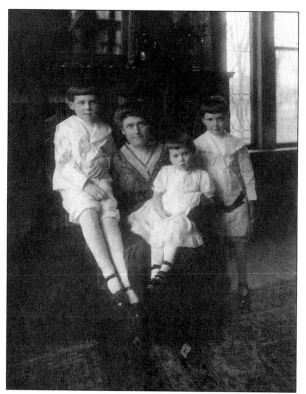

The Huntingtons raised three children, Clark, Mary Margaret, and Walter, pictured left to right with their mother, Mary. Henry, a lawyer and probate judge, died in 1912. After Mary's death in 1968, the home passed to Clark, who lived there until his death in 1998. The Huntington House Museum exhibited art in the house between 2001 and 2005, and the J. Morrissey Company converted it into offices in 2006.

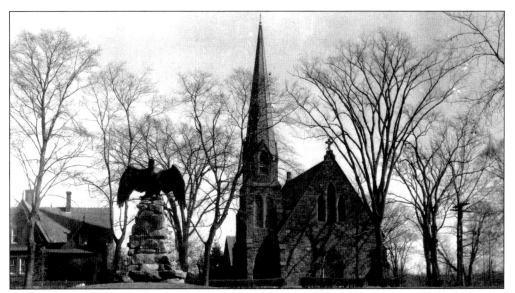

In the 1860s, Windsor's Episcopal parish hired George Keller, the architect of the Memorial Arch in Hartford, to design its new church and parsonage at the southeast end of the green. Consecrated as Grace Episcopal Church in 1865, the new church featured sandstone masonry, a slate roof, and large stained-glass windows. Also visible in this photograph is the Windsor War Memorial statue sculpted by Evelyn Longman Batchelder in the 1920s.

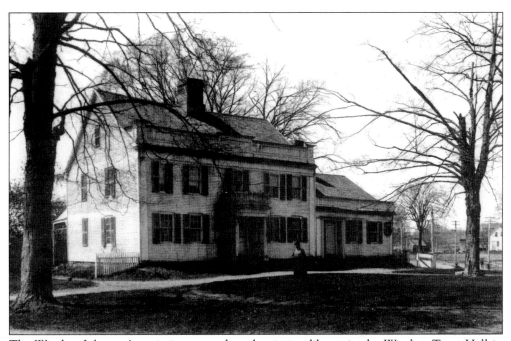

The Windsor Library Association opened a subscription library in the Windsor Town Hall in 1888 and moved from one temporary location to the next during the 1890s. In 1895, the library became a free public library, and in 1901, it settled permanently in the 1777 Col. Oliver Mather house at 325 Broad Street. Originally the librarian lived in the main house while the library was located in the one-story addition.

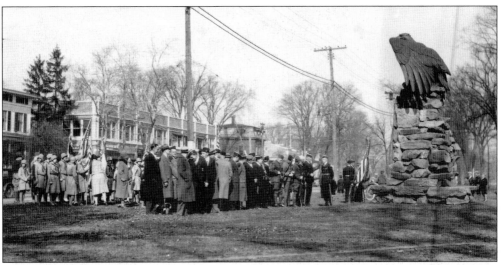

Internationally known sculptor and Windsor resident Evelyn Longman Batchelder designed a bronze eagle statue for the green's southern end. Dedicated in 1929 as the Windsor War Memorial, Batchelder's sculpture honors the "patriots of Windsor" who defended Windsor throughout its history. The statue has been the site of many ceremonies, including the 1940 Armistice Day (Veteran's Day) celebration pictured here. The Plaza building, located west of the statue (back, center), was also erected in 1929.

According to town lore, the elm trees that once encircled Broad Street Green were planted in 1755. The elms towered over the green until they became infected with Dutch elm disease in the 1940s and gradually died. Over 150 people gathered to watch town workers remove the green's last giant elm on August 2, 1950. Several of the onlookers were injured when bees swarmed from a hollow in the tree.

William H. Filley built his home at 276 Broad Street with bricks from his family's brickyard. The building, erected in the 1870s, later housed the Old Town Tavern, Robert's Travel Bureau, and several apartments. The post office bought the property in 1939, razed the house, and erected a new post office building in 1941. The post office sold the building to the Windsor Veterans of Foreign Wars in 1964.

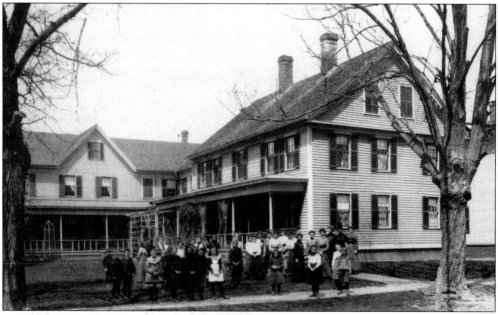

In 1867, Hezekiah Sidney Hayden founded Hayden Hall, a day and boarding school for young women. The school included a boardinghouse at 260 Broad Street and an academic building at 17 Maple Avenue. Marian Blake Campbell and Alfred Hills Campbell purchased Hayden Hall in 1903 and renamed it the Campbell School for Girls. The school closed in 1919, and the former dormitories were rented as apartments for several decades.

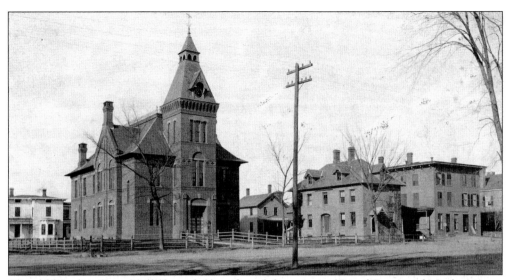

The old Windsor Town Hall (front, left) anchored the corner of Broad Street and Maple Avenue from 1878 until its demolition in 1967. Looking north, the post office occupied 262 Broad Street (front, center), currently the Windsor Donut Shop, between 1888 and 1924. The Murphy building (front, right) housed Michael Murphy's store in the 1880s and John and James Garvan's store in the early 1900s, and is the site of the Taste of India restaurant today.

Everett Hayden's Victorian house at the southern corner of Broad Street and Maple Avenue, pictured on the left, was demolished in 1945. When plans for a commercial building on the site failed, the lot stood vacant until the Windsor Federal Savings and Loan Association purchased it in 1952 and turned it into the town's first public parking lot. Windsor Federal built a modern bank building on the site in 1956.

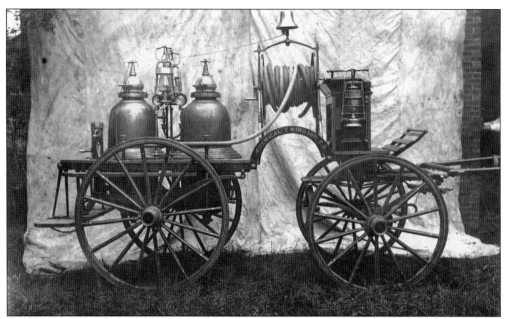

The Windsor Volunteer Fire Company formed in 1830 but struggled after a fire destroyed its building and equipment in 1869. The company reorganized in 1880 and moved to a new firehouse on Maple Avenue behind the town hall. In 1901, the company bought a horse-drawn chemical fire engine to replace its antiquated hand-pumped machine. The new engine doused flames with 100 gallons of bicarbonate of soda mixed with sulfuric acid.

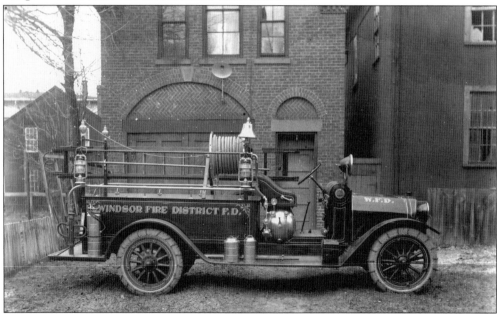

In order to receive town funding for a motorized fire truck, the Windsor Volunteer Fire Company joined the District Fire Commission in 1918 and became the Windsor Fire District Fire Department. The department purchased a motorized fire truck in 1918 and built a new firehouse at 20 Union Street in 1927. In 1991, the Windsor, Wilson, Poquonock, and Hayden Station fire companies combined to form the Windsor Volunteer Fire Department.

Windsor's first post office was located in Nathaniel Howard's store at 96 Palisado Avenue, currently the Windsor Historical Society's John and Sarah Strong House. The post office relocated to Broad Street around 1840 and occupied this building at 262 Broad Street from 1888 to 1924. The post office moved to the Windsor Casino and then to the corner of Elm and Broad Streets before settling at 245 Broad Street in 1963.

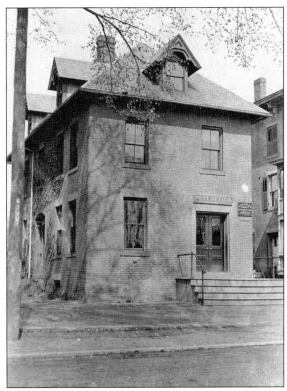

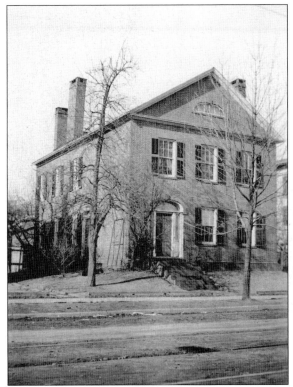

Col. James Loomis and Abigail Chaffee married in 1805 and built this home at 208 Broad Street in 1822. They shared the house with their children and Nancy Toney, a slave Abigail received as a wedding present. Toney was too young for freedom under Connecticut's 1784 gradual emancipation law and later was too frail to live independently. When Toney died in 1857, the Loomis family buried her in Palisado Cemetery.

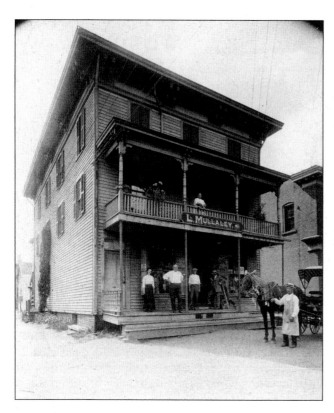

Lawrence Mullaley Jr. dealt in "groceries, provisions, and general merchandise" at his 194 Broad Street store. Mullaley was one of several Irish American businessmen to own Broad Street grocery stores around 1900. Michael Murphy opened a store on Broad Street in 1882 followed by Mullaley, John Gilligan, and John and James Garvan in the early 1900s, and James Dillon from the 1930s to 1976.

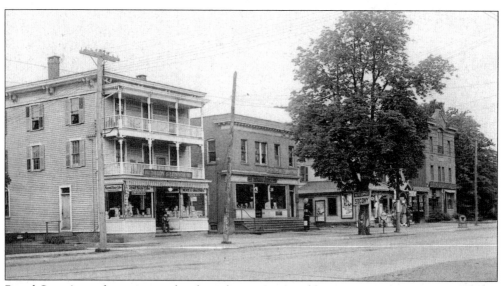

Broad Street's northwest corner has been home to many businesses. In the 1920s, the Dillon and Lennox market occupied the building that once was Mullaley's store (left). The G. F. Wilbraham store, Edward Kernan's real estate agency, and a gas station were all located in the middle of the block. The brick Ellsworth and Filley commercial building at the corner of Broad Street and Bloomfield Avenue (right) also housed a variety of offices, stores, and the Masonic lodge's headquarters.

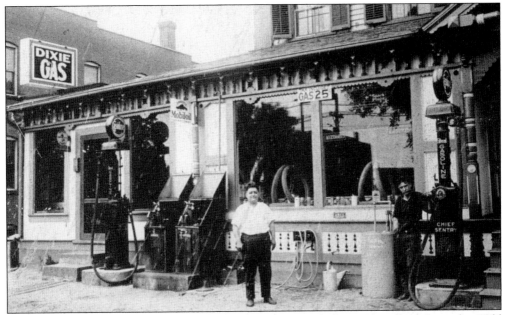

In the early 1920s, Gennaro Fusco ran a gas station and shoe repair shop from the "Old Homestead" at 176 Broad Street. Constructed for Capt. Roger Newberry in 1732, the homestead housed the Fellenberg School for Boys in 1820 and a boardinghouse in the 1890s. Fusco moved his business to Poquonock Avenue by 1927, and his family continues to run a fuel oil service in town. (Courtesy Julius Rusavage.)

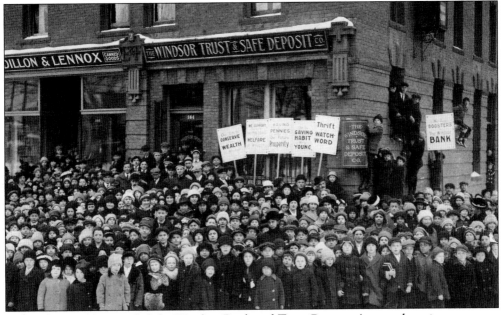

Over 1,000 people attended the Windsor Bank and Trust Company's second anniversary party on February 16, 1916. The bank, located at 164 Broad Street on the corner of Bloomfield Avenue, closed early that day and invited the whole town to a celebration in its reception room. Among the guests were 700 schoolchildren who toured the bank and received a box of candy, an orange, and a pencil.

Bloomfield Avenue, Poquonock Avenue, Palisado Avenue, and Prospect Street intersect with Broad Street at the northwest corner of Broad Street Green. In the early 20th century, the intersection was a tangle of roads and trolley lines leading to Bloomfield, Granby, Hartford, Poquonock, Springfield, and Windsor Locks. A small island of grass and trees stood at the center of the busy intersection, further congesting traffic. The island was removed in 1987 when the intersection was straightened and traffic around the green redirected. A row of 18th- and 19th-century homes ran along the north end of the green in the mid-20th century. Today two shopping plazas have replaced several of the historic homes, redefining the corner and providing another example of the green's transformation from farmland and dwelling houses in the 17th century to commercial and town buildings in the 21st century.

Seven

RECREATION

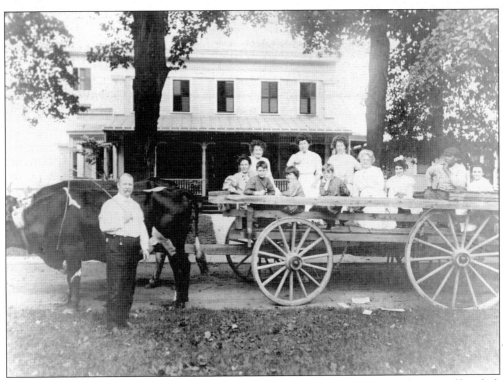

People of all ages like to take some time away from their daily chores, factory line, or office desk to enjoy a sunny day or an evening of music. Windsor folks were no exception. Outdoor sports, amateur theatricals, parades, and family picnics were even more popular in the past than they are today. Owen Eagan (standing) gathered his family and friends in front of the Hotel Windsor before setting off on an outing.

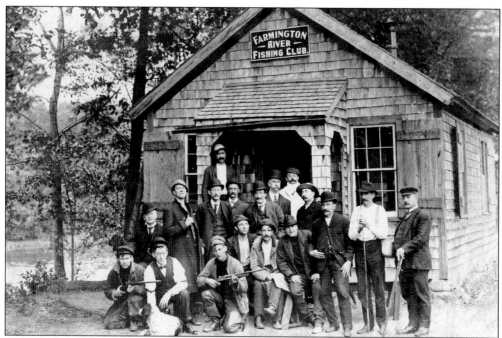

Many recreational activities in Windsor focused around the lure of woods and stream. A number of camps and clubhouses were built close to the Farmington River by groups whose members enjoyed hunting and fishing. The Farmington River Fishing Club was located behind today's Brown's Harvest near the intersection of Poquonock Avenue and Rainbow Road. Its rustic building was washed away in the 1955 flood.

The Winpoq Fish and Game Club property was located at the end of Clubhouse Road off East Street. A leaflet put out by the organization touted the spacious verandas for relaxing and open-air dancing, basement storage space for canoes, and a floating boat dock. Wednesdays were set aside for the members' wives, daughters, and their friends. All in all, the club was a dandy place to enjoy a Sunday afternoon.

Barber's Pond was a large pond near Windsor Center that drained into Mill Brook. It was noted for its trout fishing. Many other good fishing spots could be found along the length of the Farmington River where trout, bass, and pickerel tested the fisherman's skill and luck. Owen Eagan (left), owner and proprietor of the Hotel Windsor, and his friend Tom Keeney proudly showed off their day's catch in 1907.

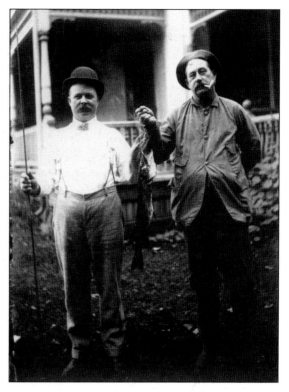

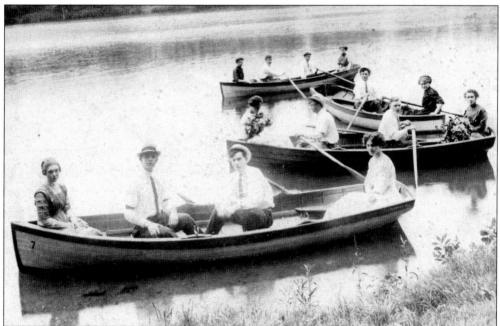

At the beginning of the 20th century, Windsor was a popular pleasure resort known for its beautiful scenery along the river. The Tunxis River Canoe Club had a large clubhouse just a short walk from the trolley car line in Windsor Center. The coed club's opening-day festivities in 1916 included a tug-of-war, swimming races, a regatta, and dancing.

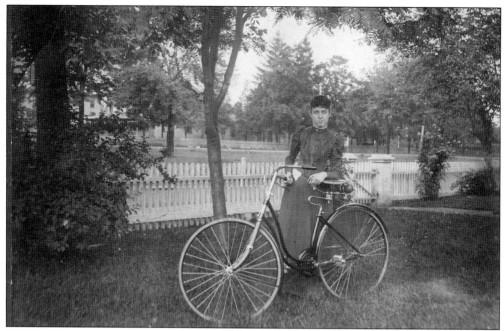

Safety cycles were the prototype of all 20th-century bicycles. The medium-sized wheels of equal diameter were chain-driven, more stable, and easier to stop than earlier models. Bloomers allowed daring young women wearing a skirt to ride a bicycle and still maintain their modesty. Myrtle Moffatt Barnes was one such young woman enjoying a fine summer day.

The penny-farthing bicycle with its dramatically large front wheel and small rear wheels was created in England in 1870. The high seat and poor weight distribution of these early bicycles made the rider prone to dangerous falls. It is likely the bikes were still a novelty when Frederick and Charles Stinson posed for this formal portrait. The boys were the sons of William Stinson, a local dealer in lumber and coal.

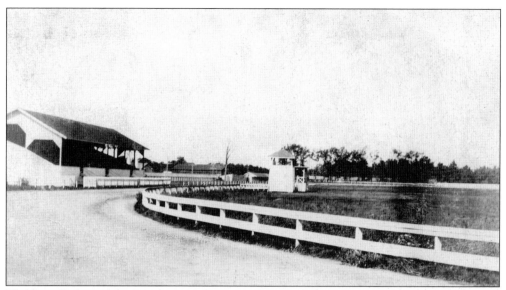

The Sage Park track in Windsor was known as "New England's Greatest Half-Mile Track" on the light-harness racing circuit. Louise H. Sage, one of the early owners, insisted on exactly parallel straightaways and evenly banked turns in order to encourage the greatest speed with the least strain on the horses. Sage Park was a venue for both training and racing from 1896 until the mid-1940s.

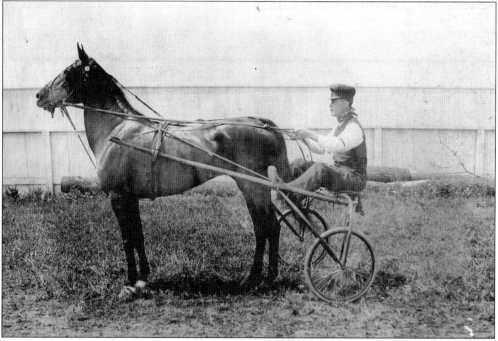

The Hotel Windsor was popular with the horsemen and racing aficionados who came to Windsor for the racing season. Red Rose and his driver, Tom Condon, were just one of hundreds of entrants each year. Several fires destroyed some of the Sage Park stables in the 1930s and 1940s. The grandstand deteriorated, and eventually the town of Windsor bought the property and built Windsor High School.

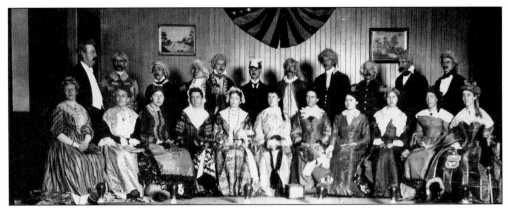

The stage in Windsor's old town hall on the west side of Broad Street was the venue for theatrical performances and musical reviews, Memorial Day exercises, and the Christmas ball. In the 1880s, a series of "Old Folks' Concerts" featured both serious and humorous solos, duets, and group numbers accompanied by the organ and a six-piece orchestra.

Pictured here is Lizette Goddard, who wore her friend's wedding dress and cap to sing in the "Old Folks' Concert" at the town hall. The musical conductor, J. Allen Francis, was a big hit as he sang "For I Ain't as Young as I Used to Be" along with the orchestra. Sometimes magician E. Palmer Tiffany performed tricks of illusion between the musical parts of the program.

The old town hall in Poquonock was used for dramatic events, parish fairs, and exhibitions of artwork and curios such as stuffed bird specimens or Native American relics. Seminary Hall was another frequently used gathering place. It was part of the Hayden Hall school, a young ladies institute at the corner of Broad and Maple Streets.

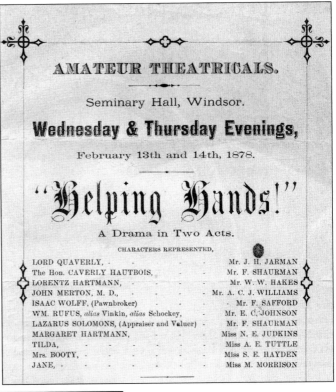

AMATEUR THEATRICALS.

Seminary Hall, Windsor.

Wednesday & Thursday Evenings,

February 13th and 14th, 1878.

"Helping Hands!"

A Drama in Two Acts.

CHARACTERS REPRESENTED,

LORD QUAVERLY,	Mr. J. H. JARMAN
The Hon. CAVERLY HAUTBOIS,	Mr. F. SHAURMAN
LORENTZ HARTMANN,	Mr. W. W. HAKES
JOHN MERTON, M. D.,	Mr. A. C. J. WILLIAMS
ISAAC WOLFF, (Pawnbroker)	Mr. F. SAFFORD
WM. RUFUS, alias Vinkin, alias Schockey,	Mr. E. C. JOHNSON
LAZARUS SOLOMONS, (Appraiser and Valuer)	Mr. F. SHAURMAN
MARGARET HARTMANN,	Miss N. E. JUDKINS
TILDA,	Miss A. E. TUTTLE
Mrs. BOOTY,	Miss S. E. HAYDEN
JANE,	Miss M. MORRISON

Earlier generations of children enjoyed dressing up and performing for an audience, too. These young people hoped they were striking an authentic pose as they showed off their Highland dress costumes of tartan kilt, sporran (fur pouch), hosiery, and buckled shoes. They were standing on the broad front steps of the Hotel Windsor about 1906.

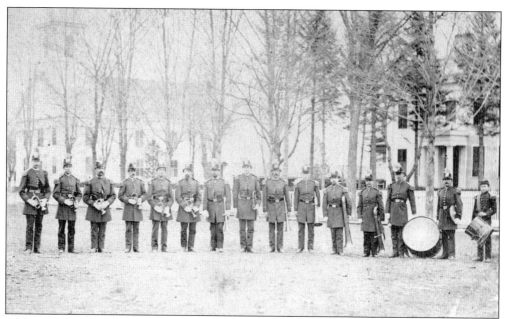

Although it was common for the members of a local band to enlist and serve together in a military regiment, the Windsor Military Band was formed in 1870 after the Civil War. This picture of the original band was taken on the Bowfield Green near the old Methodist church. Many of the founding members became prominent men in town. The band enjoyed a close association with the Windsor Fire Company.

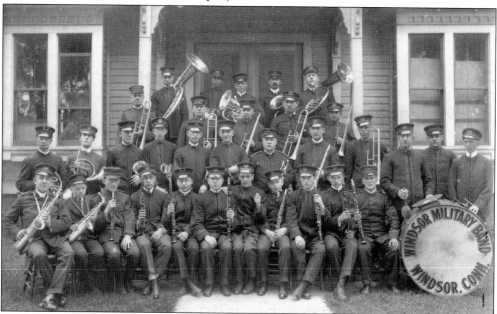

By 1910, the Windsor Military Band had doubled in size and added a variety of brass and woodwind musicians to its membership. The band played for fire company carnivals, at the welcome home celebration for World War I veterans, and for many outdoor band concerts on warm summer evenings. This picture of the band was taken in 1910 in front of the Windsor Casino just south of the Hotel Windsor.

The Greatest Event of the 19th Century!!

FUN AND FROLIC FURNISHED FREE!

—AT THE—

Grand Picnic and Ragga-Muffin Parade

—GIVEN BY THE CITIZENS OF POQUONOCK—

—AT—

Lord's Grove, July 4th, 1887.

The festivities of the day will be ushered in by the explosion of a gas bag on Poverty Hill at early sunrise, after which the Antiques and Horribles will rendezvous in their night-shirts, at Elm Grove Hall, where proclamation will be made by Chief Marshal Day. The line will then form with the right resting on the grove, and the left on Judge Hough's Tobacco Shed. The long roll will be called and the following officers will be in command.

—CAVALRY.—

Brigadier-General Day, mounted on an ice tongs,—drawn by the "Belle of Hatheway Pond."

Loo-tenant-Kurnel Dubon, mounted on a tobacco-horse,—drawn by Mike McCarthy, rigged in hoop-skirts.

Major Tom Fair, mounted on a coal-hod, holding the Book of Mormon in his right hand, drawn by Bob Ingersoll.

—INFANTRY.—

Captain Jay-cub Wolf, arrayed in new overals, mounted on a bundle of straw,—drawn by a lighted match.

Loo-tenant Sam Gray, arrayed in Brother Schaefer's overcoat, No. 55, mounted on a bar of soap,—drawn by a pair of 1776 postage stamps.

Second Loo-tenant Jim Powers, mounted on an empty lager keg,—drawn by Mrs. Wall's goat.

The Procession shall be marshalled in the following order:—

FIRST DIVISION.

The Poquonock police force, past and present, 65 in number, Ex-Chief Horace in command, mounted on Doc's skeleton.

The Poquonock Drum Corps in Oriental Costume borrowed of P. T. Barnum for the occasion.

The Swamp Angels from Rainbow, mounted on bean poles.

The Brighton Artillery in command of Dick the Darkey, mounted on a fiery gray steed.

The Left handed sharp-shoots commanded by Billy Purnell, mounted on Plymouth Rock Roosters.

The Barn-yard Invincibles, Byron Griswold in command, seated on an empty Molasses Hogshead.

The Goddess of Liberty and 38 Misses not over 55 years of age, handsomely arrayed in Mosquito Netting.

SECOND DIVISION.

The Poverty Hill Tin Pan Band, playing the Anvil Chorus on a Dulcimer.

The Sons of Rest, bearing a banner with the legend "the world owes us a living."

The Young Ladies' Sewing Society with the motto "O say did you hear."

The Shuckletown Light Brigade commanded by Lanpheare A. Addison.

Second Division.—Continued.

The Frog Hollow Invincibles protected by a Barbed Wire Fence.

The Boar Hill Rangers commanded by Billy Johnson, mounted on a Hen Halk.

THIRD DIVISION.

The Poquonock Hook and Ladder Co., Clarence Fox in command.

The United Fire Department, Chief Baxter in command. (N. B.) Visitor will please not monkey with the Air-brake.

Hon. Henry Knopp with his Stud of Trained Stallions which will travel over the entire route providing the day is long enough.

The Salvation Army Caravan who will leave their barracks commanded by William Greely. (P. S.) Moody and Sankey Hymns will be distributed free along the line.

The United Trades, including Citizens, Soldiers, Dynamiters, Hen Thieves, Justices of the Peace, Town Officers, Grocers, Fish Pedlers, Paper Makers, Barbers, Bakers, and Blacksmiths.

This Fourth of July celebration in Poquonock must have been an extraordinary event. It began at sunrise on the top of Poverty Hill (now known as Prospect Hill) and ended with fireworks. In between, the daylong schedule had something for everyone. The grand parade had so many units it seems that all of the community must have been in the procession. The rambling, light-hearted description of the parade route suggests that it wound through the southern end of Poquonock and stopped at the town hall and the Hartford Paper Company's coal yard before crossing the river and proceeding to the picnic grounds at Lemuel Lord's peach orchard. There were games and contests for all ages and refreshments of every kind, and then "when Sol's bright rays disappear beneath the horizon and Fair Luna with tender solicitude suspends her silvery lantern on the Southern skies," the evening concluded with fireworks and the Fourth of July extravaganza passed into history.

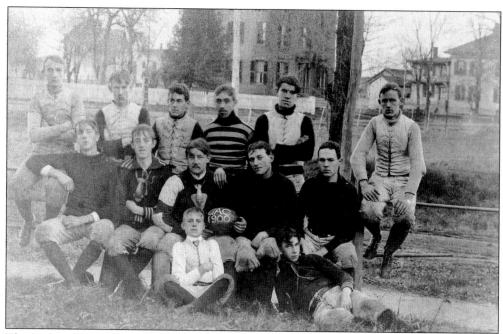

The Eagle Athletic Club of Windsor was organized in 1903. For three years it had a membership of nearly 100 men. Its football, basketball, and baseball teams played against college and community teams in the Hartford area. When it disbanded in 1906, its club room became a pool and billiard parlor.

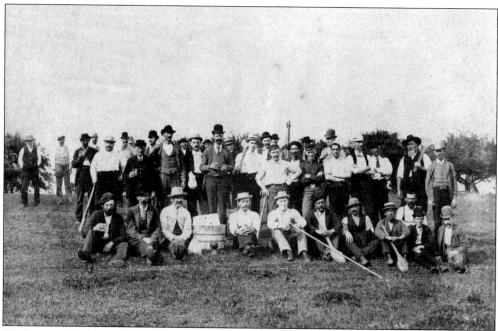

Wicket, an old-fashioned game similar to cricket, was once a popular leisure pastime. The bowler (pitcher) delivered a small, leather-covered ball toward the wicket. The wicket was a thin stick set atop a pyramid of wood and was defended by the batsman. Wicket declined in popularity as baseball became one of America's favorite sports.

Both the men's and women's basketball teams at Windsor High School played in the old town hall building before John Fitch High School was built. They played against teams in the Farmington Valley League and sometimes had dances after the games. For the 1920–1921 season, the women's team had 20 girls try out. Their coach was Katherine Judd, a French and Spanish teacher.

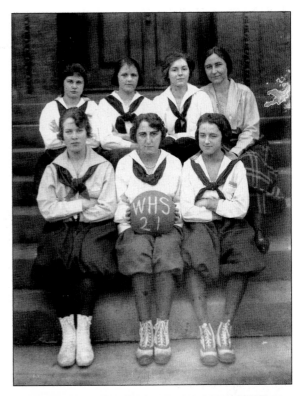

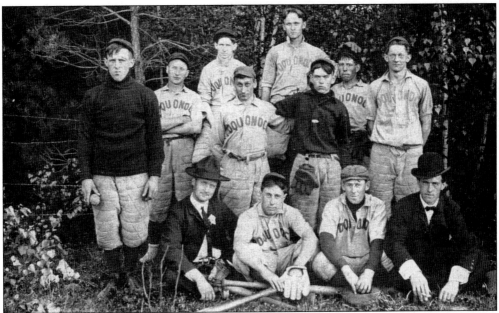

Organized sports teams became popular after the Civil War and were often sponsored by local athletic clubs, colleges, or employers. Baseball team jerseys sported a full collar during the 19th century, and the all-in-one padded pants provided protection for the players' legs during the vigorous and spirited games. The Poquonock baseball team posed for this team photograph about 1903.

Every New England child enjoyed the magic of the world turned white by an unexpected snowstorm. Charles Elder Sr., who worked for the Health Underwear Company in Poquonock, patiently waited for the photographer before giving Charles Elder Jr. a ride on his wooden sled. This snowfall was in January 1914.

Unstructured play and family time were important but rarely recorded in photographs. This young child was allowed to bring his or her blocks and little wagon outside to play by the back porch of the house at 40 Pleasant Street. The vines growing on the trellis created a shady place to play while mother snapped beans or hung up the laundry.

Eight

REMEMBERING AND CELEBRATING

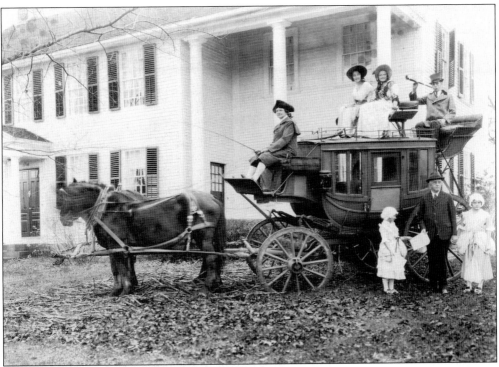

Windsor's celebrations tend to be based on its long history. When the town celebrated its 300th anniversary in 1933, the Oliver Ellsworth homestead was the backdrop for a stagecoach ride and a formal proclamation by the state's governor Wilbur Cross (standing). He is flanked by sisters Mary and Jean Ellsworth while their father, Philip Ellsworth, drives the coach.

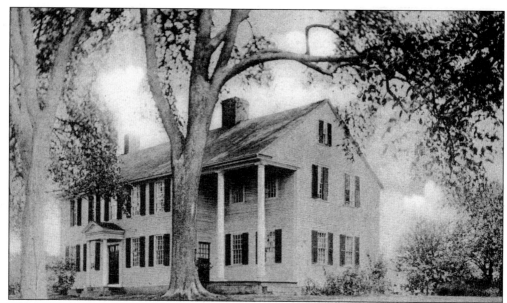

Oliver Ellsworth (1745–1807) was a descendant of a Windsor founding family and Windsor's most famous citizen. He was a lawyer, senior statesman, jurist, framer of the United States Constitution, and the country's third chief justice of the Supreme Court. He constructed his Palisado Avenue home in 1780 and died there in 1807. In 1903, his descendants donated the house to the Daughters of the American Revolution, who maintain it as a public museum.

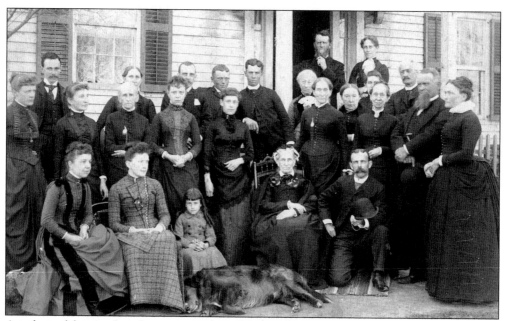

Another celebration based on age was Anna Maria Benton's 100th birthday on April 16, 1897. She was notable as the last "real daughter" of the Daughters of the American Revolution—the last surviving member whose father served in the Revolutionary War. Benton spent the occasion seated in her rocking chair using her ear trumpet to hear songs performed for her. She died the next year.

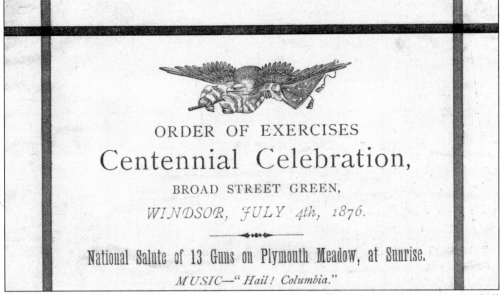

ORDER OF EXERCISES

Centennial Celebration,

BROAD STREET GREEN,

WINDSOR, JULY 4th, 1876.

National Salute of 13 Guns on Plymouth Meadow, at Sunrise.

MUSIC—" Hail! Columbia."

Windsor observed the nation's 100th anniversary in 1876 with a 13-gun salute at sunrise, bell ringing, and musical performances during the day. The town's surviving Civil War soldiers marched in a parade where the lead carriage contained 38 beautiful young ladies, each representing a state in the union. After dinner, the evening was capped off with a fireworks display on the town green. Over 3,000 people attended the celebration.

About 106 Windsor men served in the Civil War. By 1922, there were 11 Civil War veterans left, including Lorenzo Converse, Edmund Green, William Best, James Ferrier, John DuBon, Charles Daniels, Charles Lynch, A. Neuhaus, Fred Baker, Sidney Strickland, and Everett Hayden. The survivors gathered annually on Memorial Day, marched in parades, and had their pictures taken. This photograph of the sons of those Civil War soldiers was made in the 1920s.

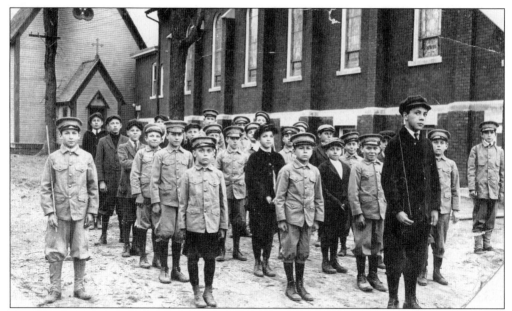

Windsor's citizens were committed to winning World War I. Citizens economized by buying thrift stamps, baby bonds, and liberty bonds. There were rallies, bees, frolics, plays, pageants, and poems written to boost morale locally and for the boys "over there." Women knitted socks and sweaters and made bandages. This battalion of boys assembled on the north side of St. Gabriel's Catholic Church. The former church building is in the background.

Consumption of alcohol in Windsor during the 1920s was against the law. With the signing of the 18th Amendment, federal law prohibited the production, sale, or transportation of any alcoholic beverages, although Connecticut never ratified this law. A number of Windsor citizens illegally brewed alcohol in their homes. Deputy sheriff Maurice Kennedy, a dogged enforcer of Prohibition laws, is shown with locally confiscated stills.

In a small rural town such as Windsor, a circus parade was very exciting. The lead elephant in the parade advertised the Windsor Cash Grocery, a store located in the center of Windsor in the early 1900s. The store was owned by John L. Bevier, who lived next door in the Mason building. Another "flying circus" came to Windsor in 1919 with nine railroad cars of dismantled airplanes.

The *Windsor Town Crier* was a monthly newspaper published by George Crosby, starting in January 1916. It continued until 1917, when World War I made paper and advertising prohibitive. The news consisted of who was visiting who in town, who was sick, and who bought an automobile. Here six young men, most of them wearing fashionable Plus Fours, are distributing the paper.

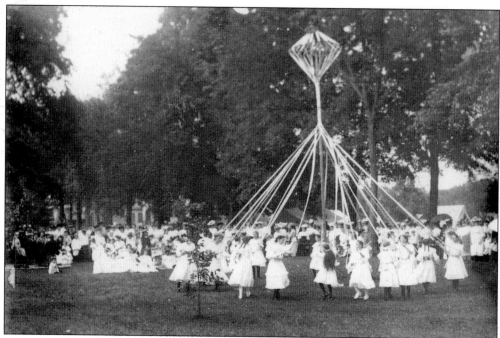

In 1902, Windsor resurrected an English country tradition—a spring celebration. The Village Improvement Society encouraged this ancient tradition with a queen and her attendants. Boys dressed as Robin Hood's merry men wore maple-leaf garlands and carried bows and arrows. Young girls dressed in white with bright hair ribbons and danced around the May pole, winding its ribbons in an intricate design.

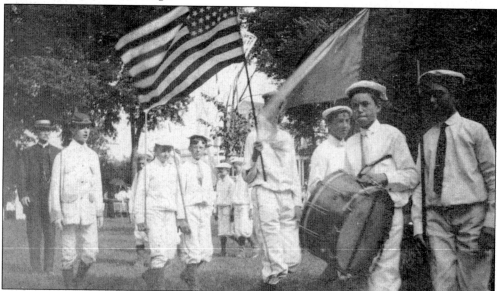

The Grace Church boys' naval battalion followed the queen and Robin Hood's merry men. When the dancing was done, they demonstrated their marching skills for the townspeople. Races were run, music was performed, and in the evening, Japanese lanterns illuminated the green while a dance was held at town hall. There were decorated food booths and flower stands. The event was called the June Day Fete since May was too chilly for these festivities.

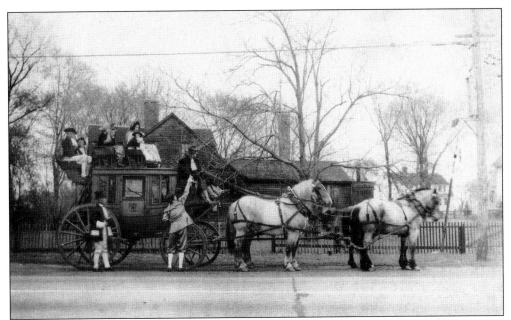

Windsor's fifth post office building was dedicated on April 26, 1941, at 276 Broad Street. The ceremonies started with a mock postal pickup at Windsor's first post office at the Windsor Historical Society (pictured above). This reenactment was staged as it would have happened in 1802, with a coach drawn by four dappled-gray horses heading south to Hartford. Mail was kept in the boot, a compartment at the driver's feet.

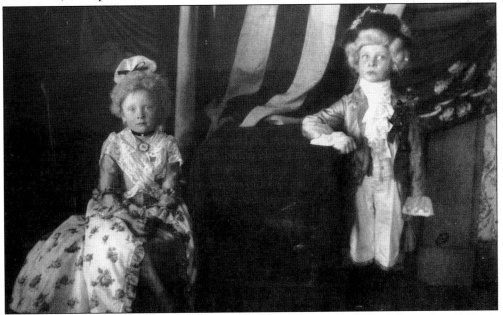

In October 1789, George Washington rode through Windsor to visit Oliver Ellsworth on Palisado Avenue. Washington became a cult figure after his death in 1799. Here a very young George and Martha Washington posed for their photograph. Theatricals were a big hit in Windsor during the early-20th century. Plays and reenactments encouraged a love of history and gave children and adults an opportunity to express these interests.

BIBLIOGRAPHY

Atlas of Hartford City and County: With a Map of Connecticut from Actual Surveys. Hartford, CT: Baker & Tilden, 1869.

De Vito, Michael C., comp. *Diary of a Trolley Road: Being the Story of the Hartford & Springfield Street Railway Company.* Warehouse Point, CT: Connecticut Valley Chapter, Incorporated of the National Railway Historical Society, Inc., 1973.

Hayden, Jabez H. *Historical Sketches.* Windsor Locks, CT: Windsor Locks Journal, 1900.

Howard, Daniel. *A New History of Old Windsor, Connecticut.* Windsor Locks, CT: The Journal Press, 1935.

O'Gorman, James F. *Connecticut Valley Vernacular: The Vanishing Landscape and Architecture of the New England Tobacco Fields.* Philadelphia: University of Pennsylvania Press, 2002.

ProQuest Historical Newspapers Hartford Courant (1764-1922) and *(1923-1984).* Ann Arbor, MI: ProQuest Information and Learning Company.

Stiles, Henry R. *The History and Genealogies of Ancient Windsor, Connecticut.* Hartford, CT: Case, Lockwood, & Brainard Company, 1891.

Thistlethwaite, Frank. *Dorset Pilgrims: The Story of West Country Pilgrims Who Went to New England in the 17th Century.* Interlaken, NY: Heart of the Lakes Publishing, 1993.

Town of Windsor Historic Survey. [Windsor, CT]: Town of Windsor Planning Department, 1981.

Trumbull, J. Hammond, ed. *The Memorial History of Hartford County, Connecticut.* Boston: Edward L. Osgood, 1886.

Uricchio, William Joseph. *The Fowles History of Windsor, Connecticut 1633-1900.* [Windsor, CT]: Loomis Institute, 1976.

Wadsworth Atheneum. *The Great River: Art & Society of the Connecticut Valley, 1635-1820.* Hartford, CT: Wadsworth Atheneum, 1985.

Windsor Storytellers: A Chronicle of 20th Century Life in Windsor, Vol. I and II. [Windsor, CT]: Town of Windsor, 1999 and 2000.

Windsor Town Crier. Windsor, CT: Town Crier Publishing Company, 1916–1917.

INDEX

ACROSS AMERICA, PEOPLE ARE DISCOVERING SOMETHING WONDERFUL. THEIR HERITAGE.

Arcadia Publishing is the leading local history publisher in the United States. With more than 3,000 titles in print and hundreds of new titles released every year, Arcadia has extensive specialized experience chronicling the history of communities and celebrating America's hidden stories, bringing to life the people, places, and events from the past. To discover the history of other communities across the nation, please visit:

www.arcadiapublishing.com

Customized search tools allow you to find regional history books about the town where you grew up, the cities where your friends and family live, the town where your parents met, or even that retirement spot you've been dreaming about.